Superior Perspectives

Views of Lake Superior from Park Point

Photographs and text by Paul Treuer

Design by Natalija Walbridge
Photograph perparation by Charles Walbridge
Printed in Duluth, MN by ProPrint, Inc.

ISBN: 978-1-947237-08-7
Library of Congress Control Number:
2019932877

Published by: Nodin Press
5114 Cedar Lake Road
Minneapolis, MN 55416

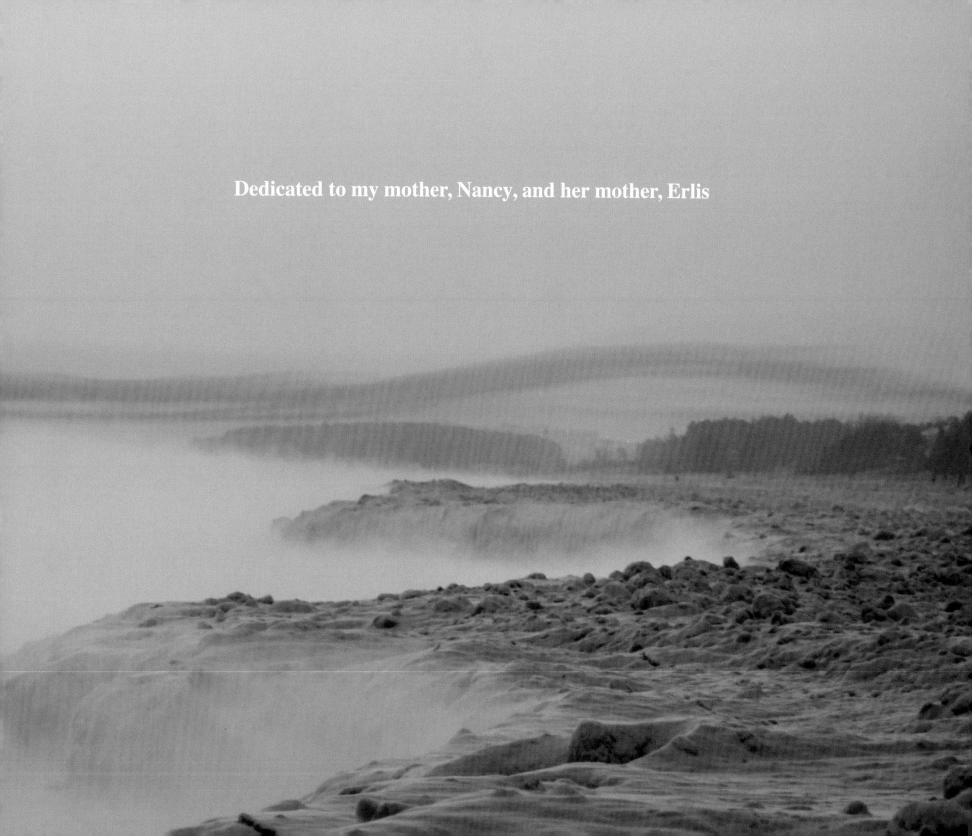

Dedicated to my mother, Nancy, and her mother, Erlis

Contents

Valentine's Daze

A broad expanse of ice and snow blankets the beach and lake. February warmth melts the heart of Old Man Winter.

March 15, 2015, 7:09 AM, 154 mm

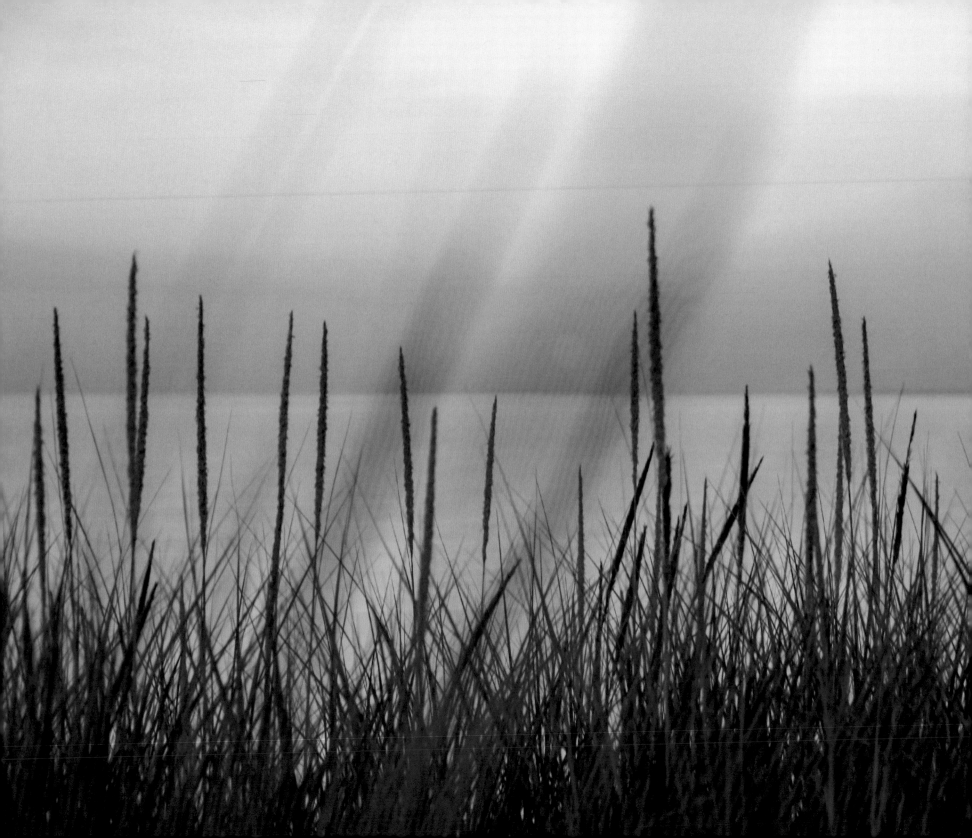

Introduction

Lake Superior has loomed large in my life almost as far back as I can remember. When I was a child, my family would stop in Duluth, Minnesota, to get supplies and spend the night while on our way from Wisconsin to wilderness canoe trips in northern Minnesota. During those stopovers I would go down to the lake shore, skip rocks, and gaze dreamily at the waves and the distant horizon; I felt an attraction for the lake that was strong and deep, like love for another person. While in my late teens, I hitched a ride on a saltwater freighter leaving port in Duluth and crossed the Great Lakes, the St. Lawrence Seaway, and the Atlantic. Later, in my mid-forties, I circumnavigated Lake Superior by kayak.

I have taken numerous camping trips along the lake and on the islands of Lake Superior in Wisconsin, Minnesota, Michigan, and Ontario. And of course, day trips in and near Duluth have been many, especially after I made Duluth my home, first for college and later as the place in which my family and I established roots. Throughout years of living in Duluth, my dream has been to live not just near Lake Superior, but to live on the lake shore itself.

After more than thirty years of living in Duluth, that dream came true! I moved with my family from the Duluth hillside, with its panoramic view of the lake, to the sandy shoreline of Park Point.

If you pictured Lake Superior as a wolf's head, Park Point would cross the very tip of its nose. Five miles long and never more than a few blocks wide, it's purported to be the world's largest freshwater sandbar. Connected to the rest of Duluth by the city's iconic lift bridge, Park Point's shoreline is sand beaches and dunes, behind which stand a narrow strip of homes— the first barrier to the wind that, when it's from the north and east, blows unobstructed across several hundred miles of open water. The feel and sound of the lake is omnipresent in this tight-knit community.

An extraordinary thing happened to me after I moved to Park Point. The beauty of the lake became manifest. How else can I describe the experience? There are many times when I see a spectacular view of the lake, drop what I'm doing, and run out of the house to observe the unique patterns of colors and lights and sounds directly. These displays often change within seconds as winds whip water and sky into new configurations like wet paint that never dries. On a recent visit to our home, our granddaughter woke early in the morning and roused me. She excitedly pointed out that an inside wall of our house, though painted green, had changed to fiery red as it was illuminated by the sunrise. "Did you see the sunrise? Did you see it?" she exclaimed. Together we rushed out to look at the sky and lake displaying a panorama of brilliant, multi-hued reds that extended as far as we could see. Sky and lake merged into a glorious landscape painting.

Before long I began taking photographs of these dramatic scenes. They serve as a way of capturing and sharing images of the extraordinary drama and beauty I'm witnessing. They also help me to remember details of beautiful effects so fleeting as to vanish or change in a matter of seconds. The fact that the photos are all taken from the same place underscores the remarkable daily and seasonal changes I'm experiencing. Bitter cold, gale-force winds, dancing sunlight, heat meeting sub-zero air, and perfectly calm weather are just a few of the factors that influence the lake's ever-changing aspect.

Time of day and the change of seasons also have a part to play in these extreme variations in mood, color, and texture. I have arranged the photos included here, taken in the course of twelve years, under an umbrella of seasonal variations starting with winter. Such vivid displays of beauty are dazzling; they call me to the lake shore again and again, like a siren song, to look more closely, to relish the subtleties, to stand in awe of what water and light and air can do. The small place from which these photographs were taken is my personal listening point; this is my spirit home. I invite you to view and enjoy these images of one of Nature's greatest wonders, the landscape that is Lake Superior.

Paul Treuer
February 2019

All photographs were taken at the same location on Park Point in Duluth, Minnesota. Photographs were taken with a FujiFilm FinePix S2000 prior to 2009. Begining in 2009 they were taken with a Canon EOS Rebel xTi. Date and time and zoom lens settings are indicated for each photograph. Colors are represented as observed and have not been enhanced.

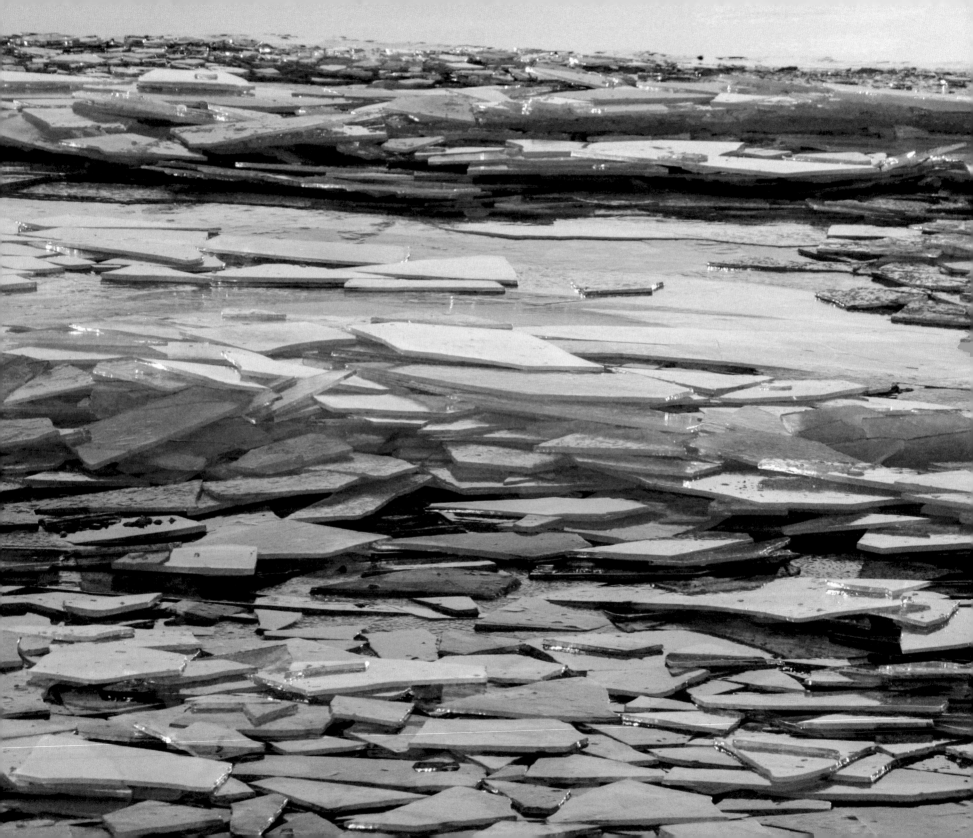

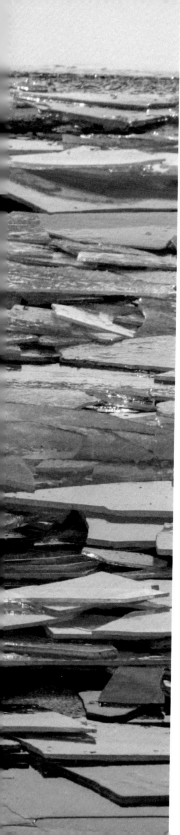

Winter

Winter along Lake Superior starts when autumnal breezes and cool night temperatures are edged out by easterly winds blowing down the lake. This is followed by a shift in wind direction to the northwest and a drop in air temperatures below zero. The onset of winter isn't a calendar date. Rather, it is the day along the shore of Lake Superior when ice begins to form. I call this Ice Day. It is a day that happens as early as November; usually, however, it is in December. The last few years it hasn't happened until January.

When easterly November winds are extreme, gales power the lake into a fury that may prove problematic for watercraft. The Socrates, a salt-water freighter, was moored less than a mile off shore from Park Point in November 1985, while waiting for a shipping terminal to open up in the Duluth harbor, when such a gale blew up. That wind not only pulled the ship from its moorings but beached it in shallow water near Park Point. Initial attempts to free the freighter failed. While waiting for tugs, temperatures dropped below zero. Waves crashed over the Socrates, coating it in ice. Weeks later, with the assistance of six tugs, the Socrates was freed and towed into port where it was repaired and loaded with grain. It quickly departed so as not to be trapped by ice on Lake Superior for the winter. The beaching of the Socrates coincided with Ice Day in 1985.

When Ice Day happens, mounds of ice rapidly build in a myriad of forms. Spewing water freezes upon exposure to the air, landing as ice formations that look like volcanoes. At other times, freezing water is arranged in mountain ranges that build over the winter to be over twenty feet high. Perhaps most magical of all is when sheets of ice are piled into fortresses and coated in freezing lake water. The resulting caves, complete with stalactites, dazzle intrepid explorers.

Following the first formation of ice ridges, sheets of ice form near shore only to be blown by southwest winds further out into the open lake. Then, with a shift to an east wind, the ice returns to shore. When the lake is perfectly calm during an extended freeze, new ice is flat. One year, when this happened, many people flocked to hike and skate on the endless skating rink. A hockey team was seen skating, like a tightly bound flock of water birds, on the vast expanse of ice that reflected the sky perfectly.

When the ice is snow covered it has an appearance of being a tundra. This landscape doesn't last long; wind and wave action breaks the ice into smaller pieces. The resulting sheets of ice are clear as glass. Sometimes they are light blue, as if sky is trapped within. Pieces of ice bob and weave and move in response to the wind and waves, and then, when the air is cold enough, they are frozen in place. Configurations of ice and snow provide the illusion of a winter still life, but as spring approaches, increasing wind and water movements quickly change that landscape.

Days lengthen in January and February, illuminating the ice and snow and open water in brilliant winter light. Predawn colors on a seemingly barren landscape are magnificent reds and blues. Could I freeze time, it would be the beginning of February when it is both cold and sunny, when the ice-covered lake and the air above are crystal clear and bright. Alas, the sun's warmth is too much. Icebergs break into smaller and smaller pieces of ice that melt in a sea of cold water and forceful waves before washing up on the shore to fight a losing battle with warming sands.

Changes in the winter landscape from year to year are well documented. Minnesota Sea Grant reports, "from 1973 to 2010 there has been a 79 percent decrease in ice cover on Lake Superior." Majestic ice formations are not necessarily seasonal; they are unique to our times.

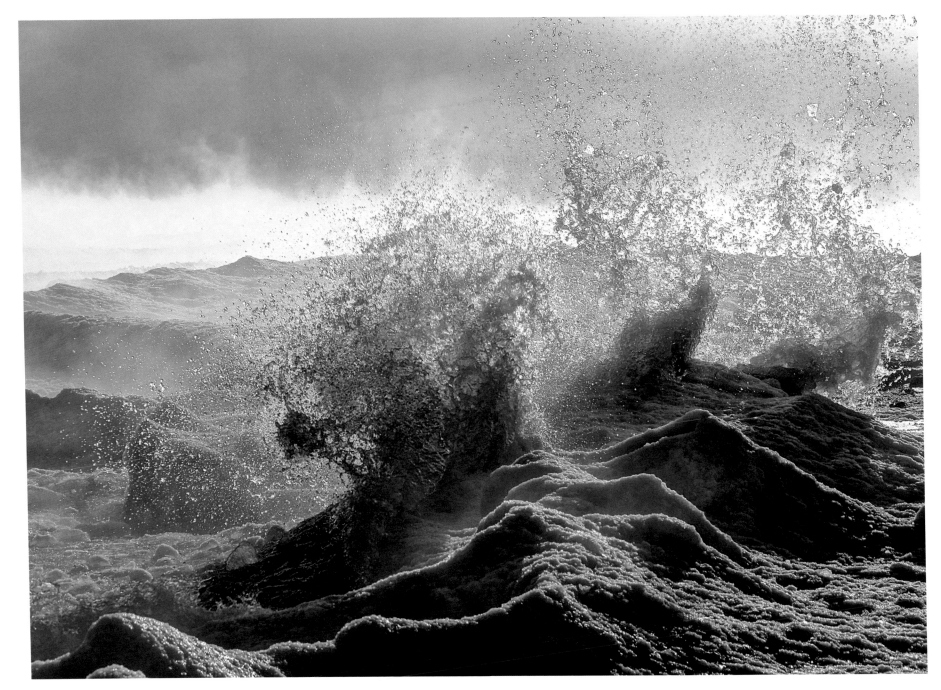

Winter Lake Effect

January water temperatures are in the mid-30's. Today the waves freeze in mid-air when the air is 10 below zero.

January 4, 2015, 10:52 AM, 74 mm

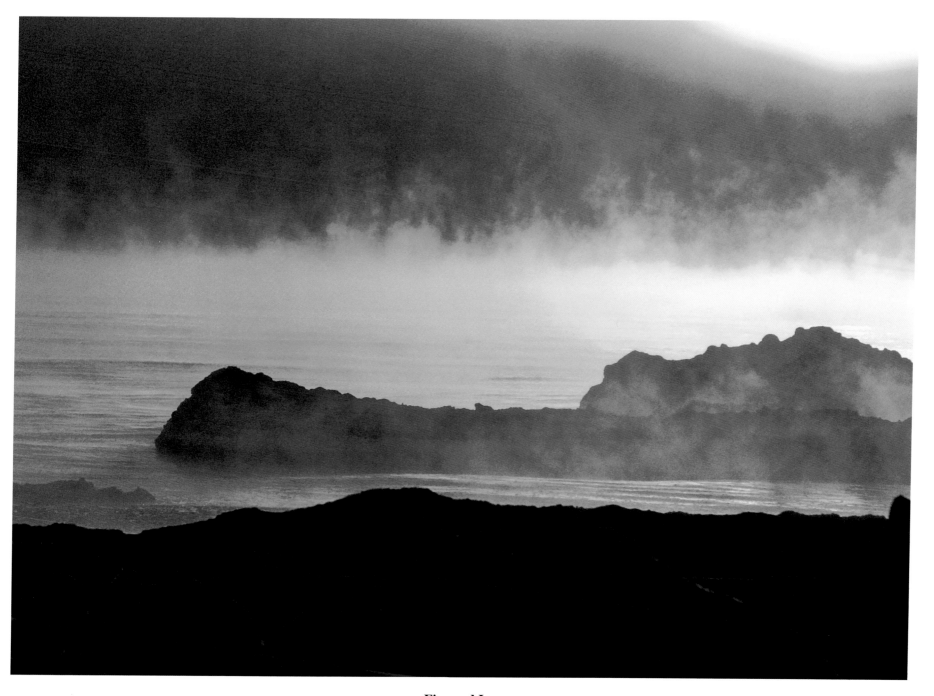

Fire and Ice

Ridges of ice are separated by open water. Mist, warmed by the lake, is aglow in the bitterly cold sunrise.

December 15, 2013, 9:06 AM, 220 mm

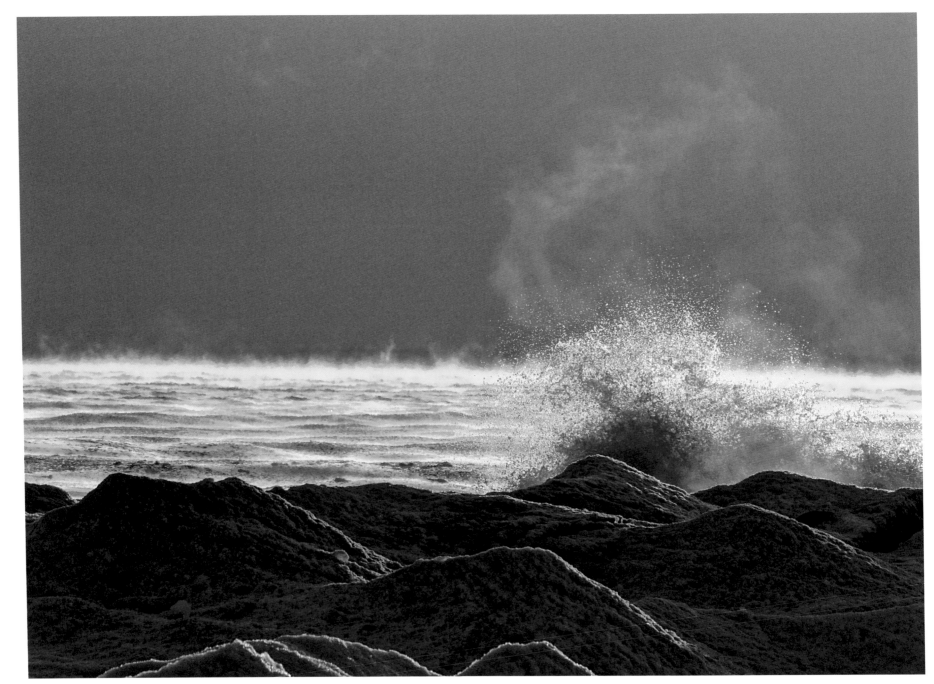

Glacial Moraines

Air temperatures are below zero and the wind is still. Waves from yesterday's northeast wind build a new shoreline.

January 8, 2010, 9:32 AM, 250 mm

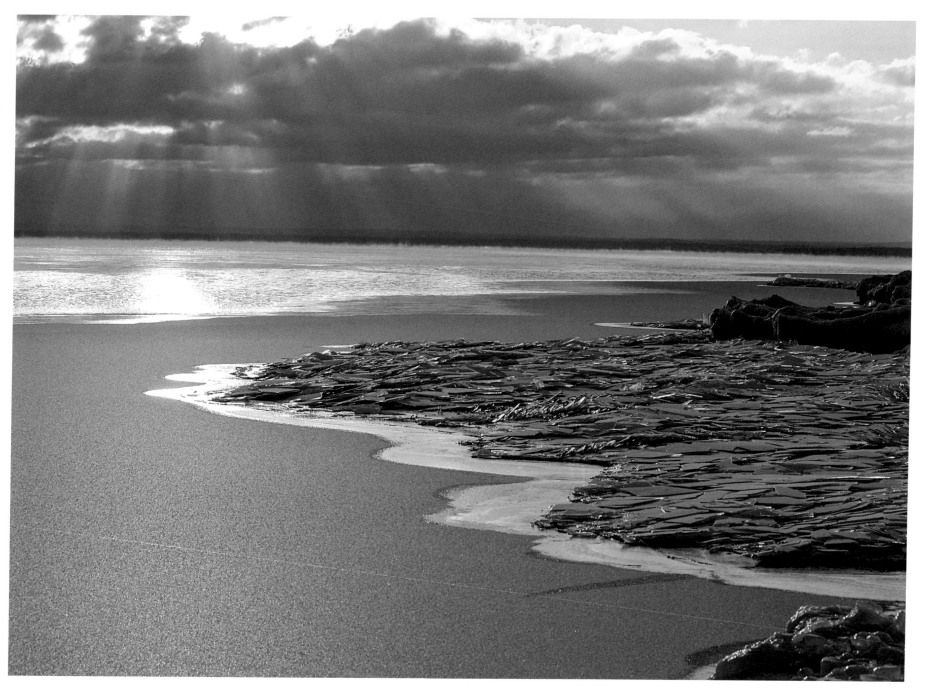

Igneous Ice

Ice accumulates on the sandy beach, creating a rugged shoreline of multifaceted ice.

February 3, 2013, 9:26 AM, 55 mm

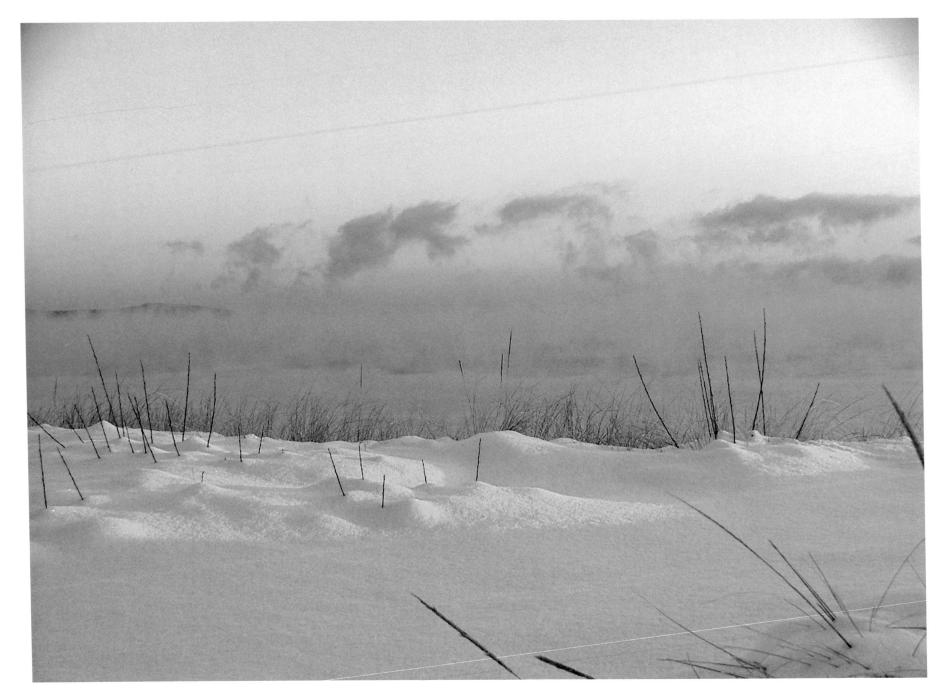

Winter Bliss

Soft pink light in the fresh snow and golden dune grass is a gift from an early winter sunrise.

December 8, 2007, 10:08 AM, 6.5 mm

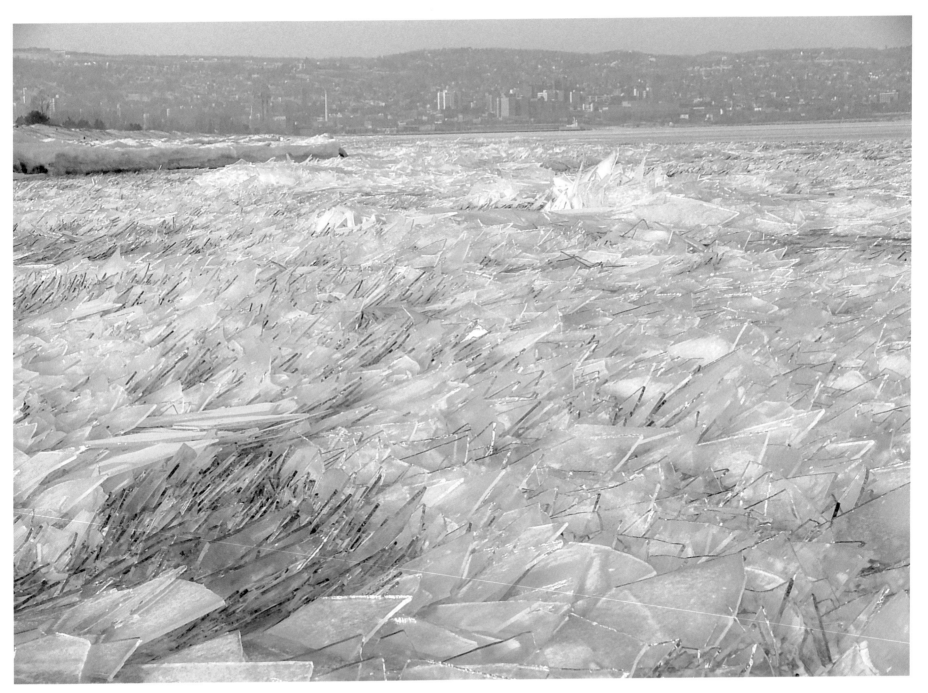

Perfect Pitch

Against a backdrop of Duluth, the lake rises up in full chorus, singing a delicate ode in tiny whispers.

February 3, 2008, 2:12 PM, 13.6 mm

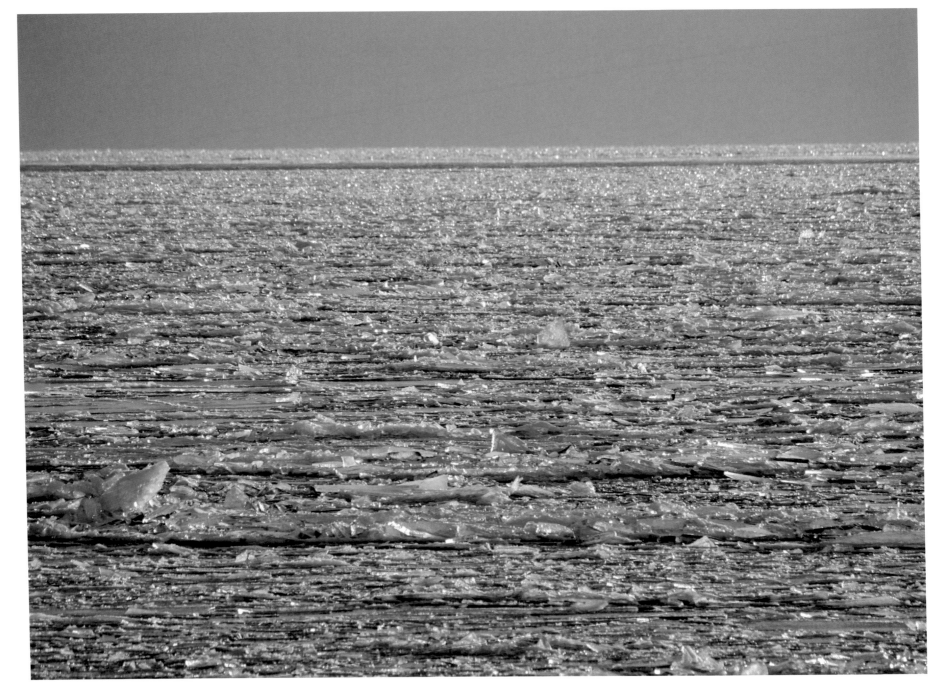

Ice-bound Infinity

Multi-shaped pieces of ice are fused in place by extreme cold as far as the eye can see.

February 14, 2010, 8:35 AM, 250 mm

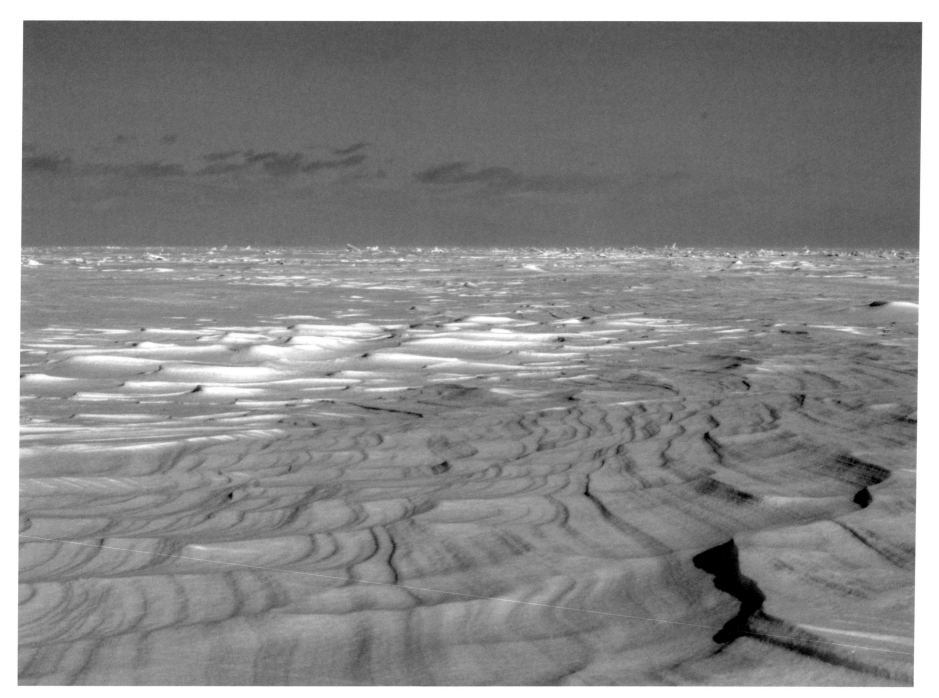

Grand Expanse

Snow accumulating on the ice-covered lake is sculpted by the wind like sand stretching across an arid land.

February 22, 2014, 3:35 PM, 55 mm

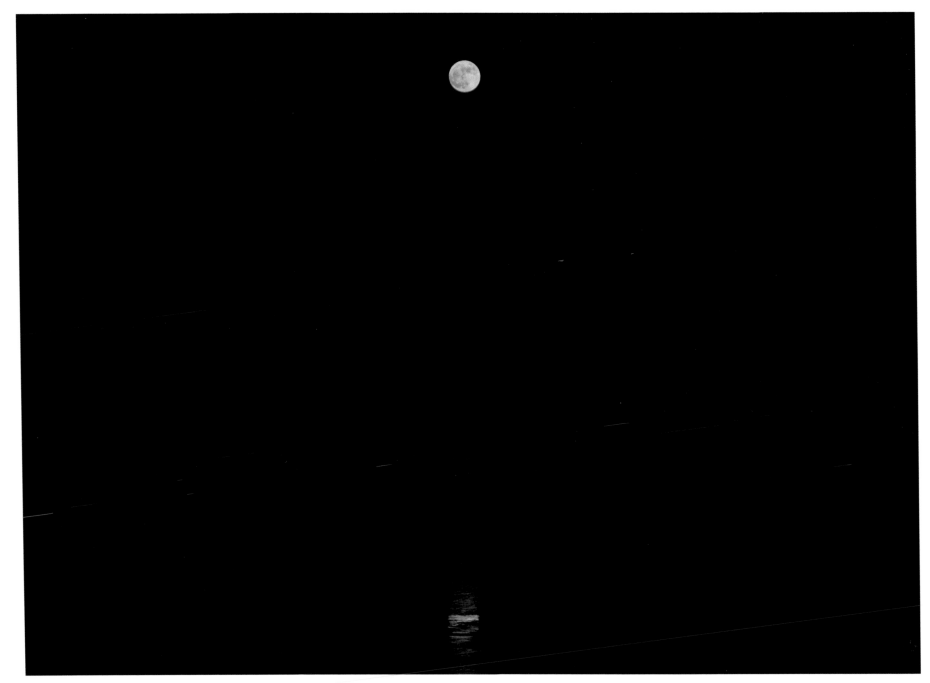

New Years Day

The full moon celebrates the new year by casting its net of delicate light across icy open water.

January 1, 2018; 6:08 PM, 70 mm

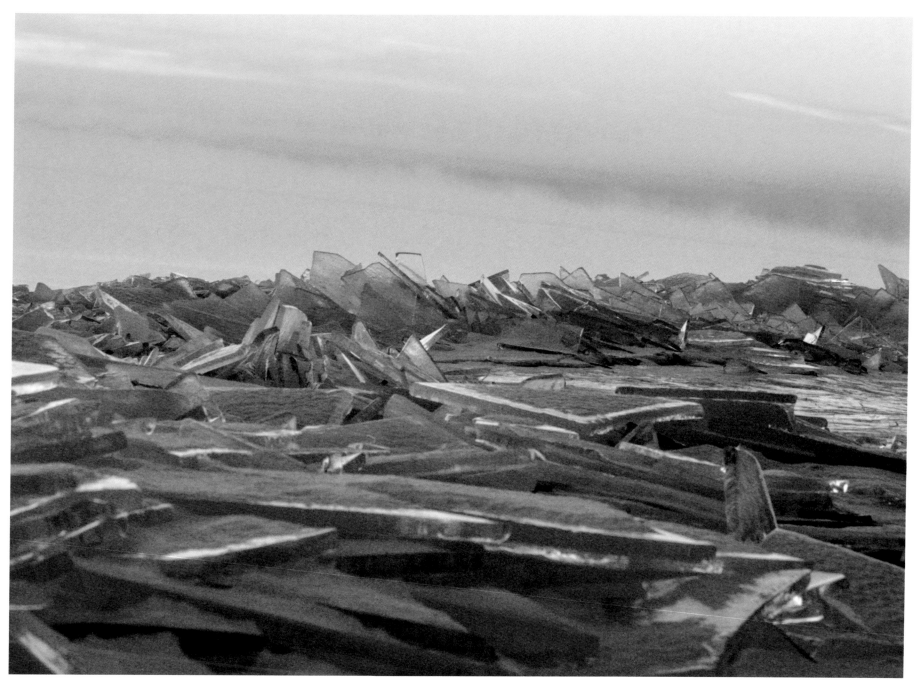

Scattered Dreams

An endless sheet of flat, glass-like ice is transformed into another equally transient reality.

February 8, 2014, 8:29 AM, 79mm

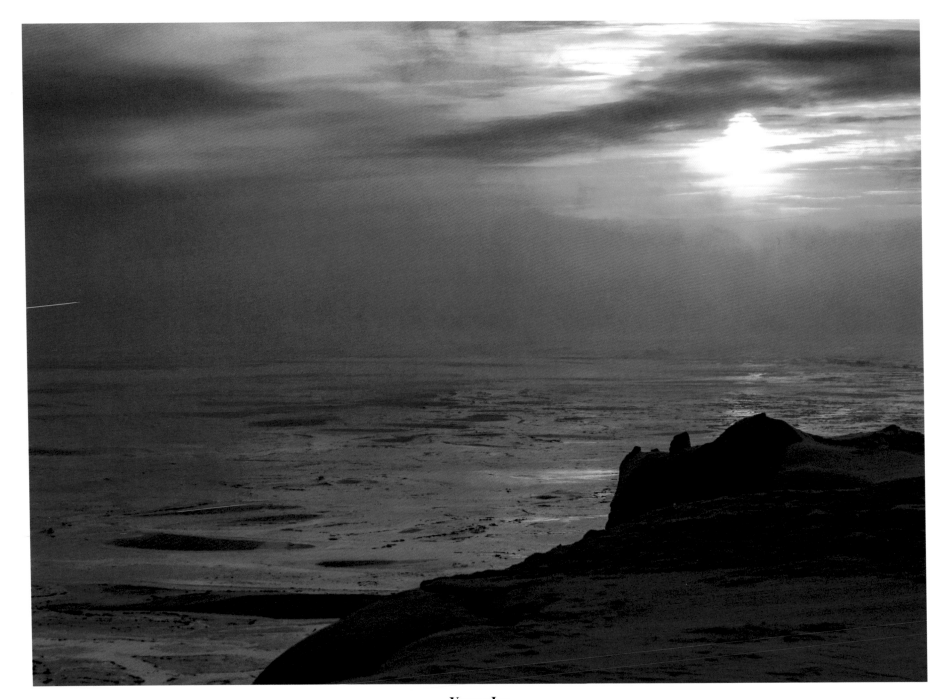

Young Ice

Soft and pliant, a thin membrane of newly formed ice undulates with each breath of the living lake.

January 25, 2019, 9:04 AM, 75 mm

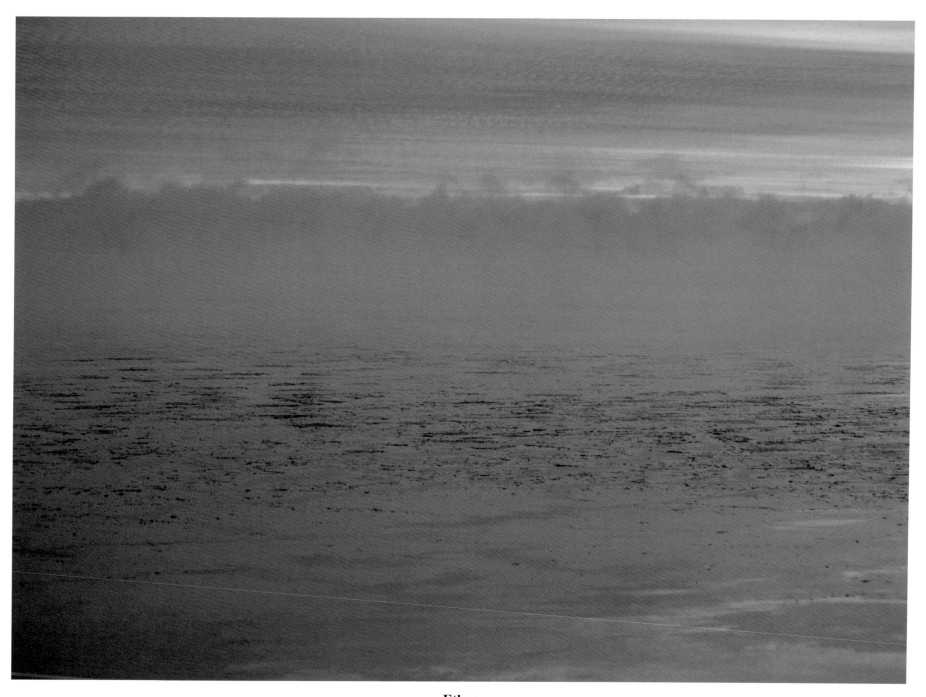

Ether
The primordial elements in water and sky are ethereal, indeed!

January 8, 2017, 8:40 AM, 70 mm

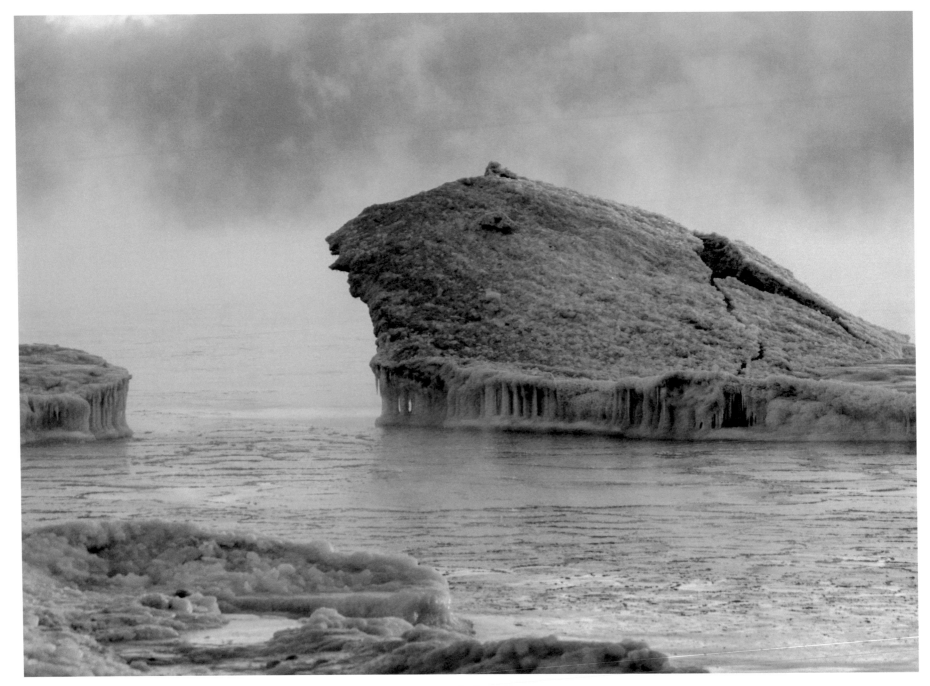

Glacial Break-up

Remnants of a 20-foot-high ice ridge are grounded like a whale waiting for its return to the lake.

January 17, 2016, 9:09 AM, 100 mm

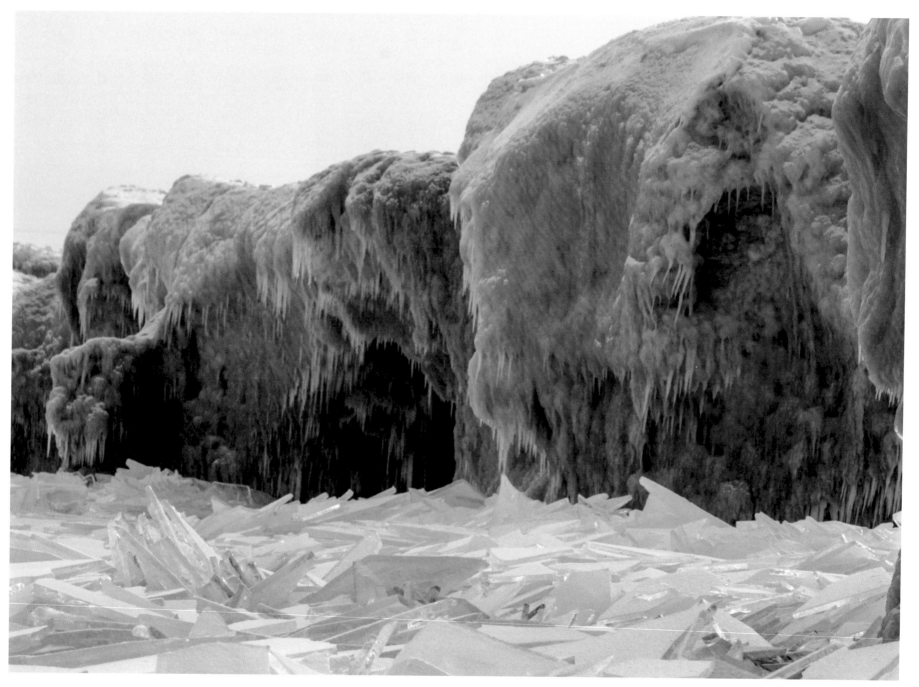

Woolly Mammoth

Like prehistoric mammals, massive ice formations along the shores of Lake Superior may be a relic of the past.

January 11, 2009, 1:19 PM, 215 mm

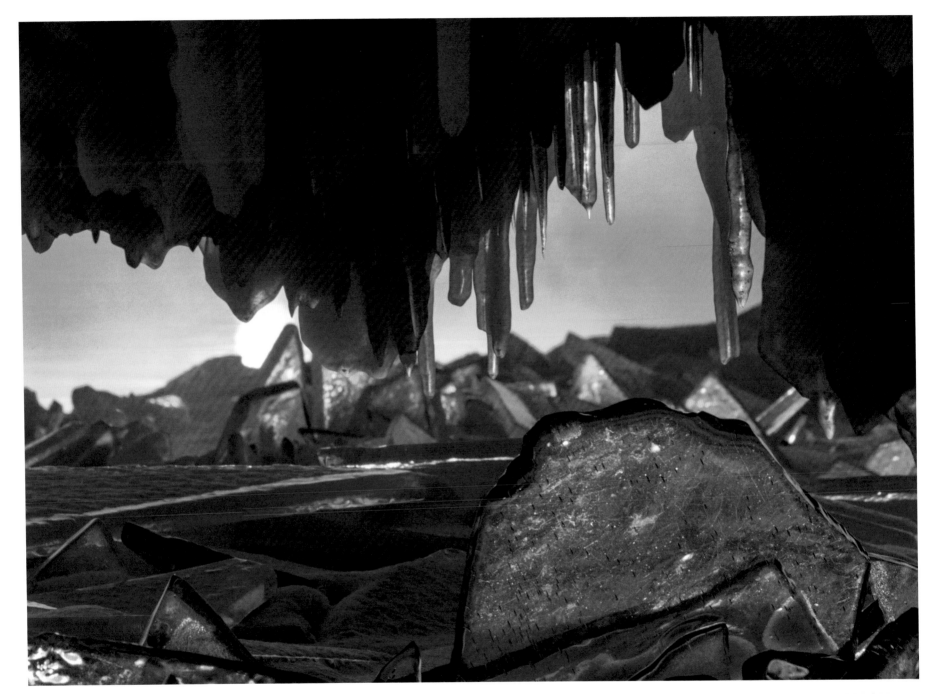

Ice Cove

Morning light pauses to reflect while passing through ice crystal prisms.

February 8, 2014, 8:37 AM, 135 mm

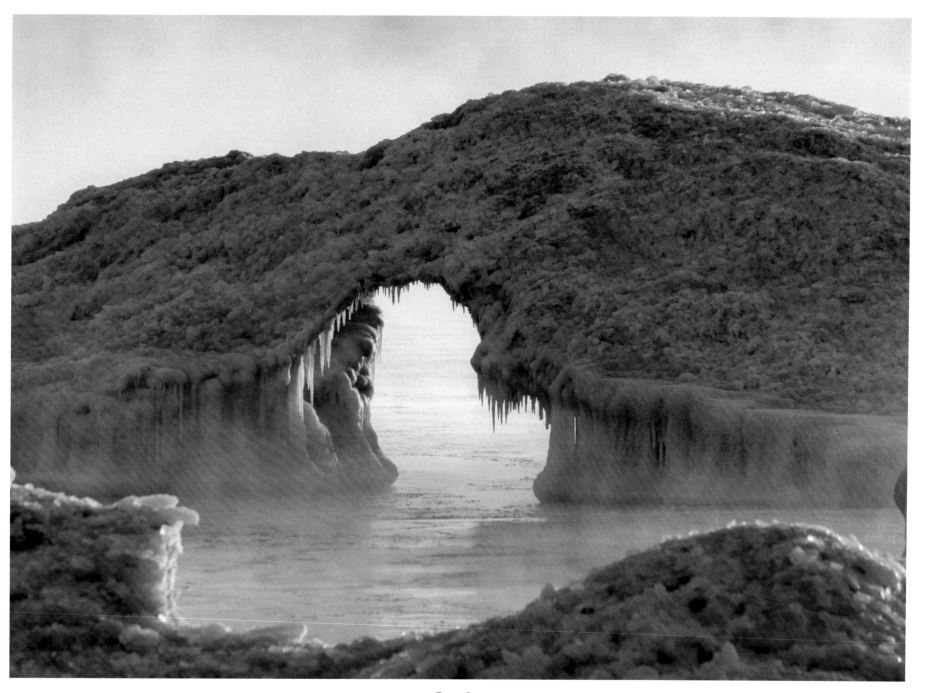

Opening
Sunlight and water flow freely through an opening in winter's grip.

January 17, 2016, 9:24 AM, 240 mm

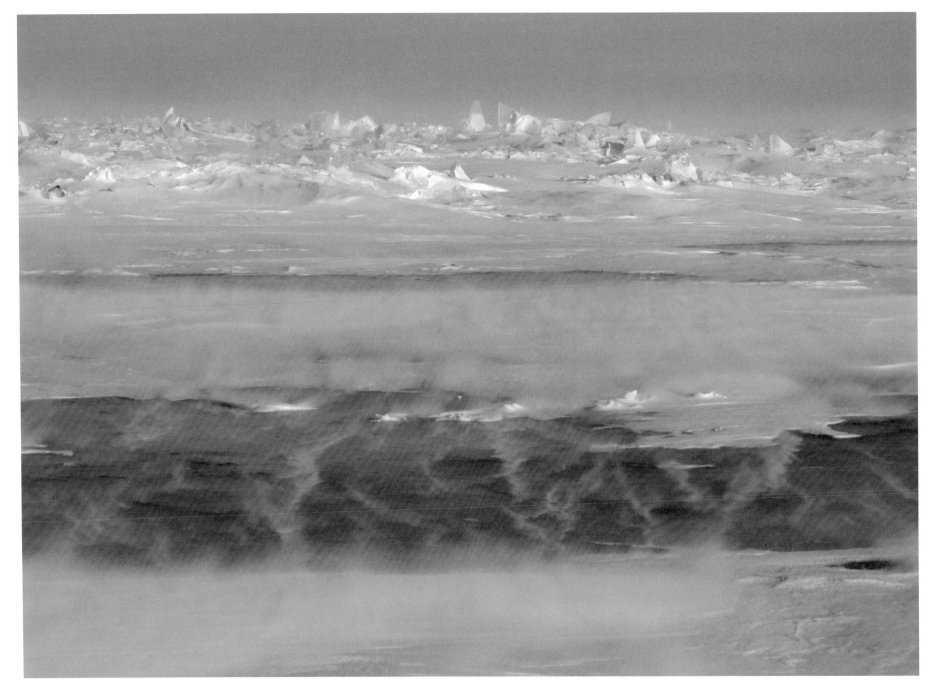

Windswept

Raging winds, blasting snow, glare ice, and rocky ice ridges mimic a scene from an Arctic expedition.

February 24, 2019, 5:00 PM, 75 mm

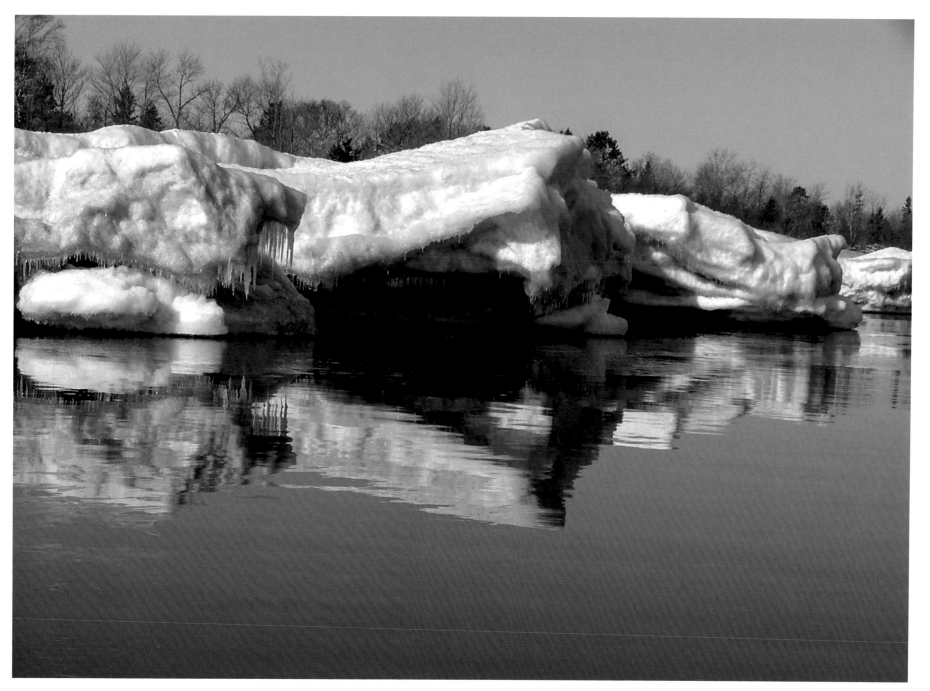

Reflections

The lake and adjacent shoreline hold their collective breaths for a portrait viewed from a kayak.

February 12, 2006, 10:17 AM, 12 mm

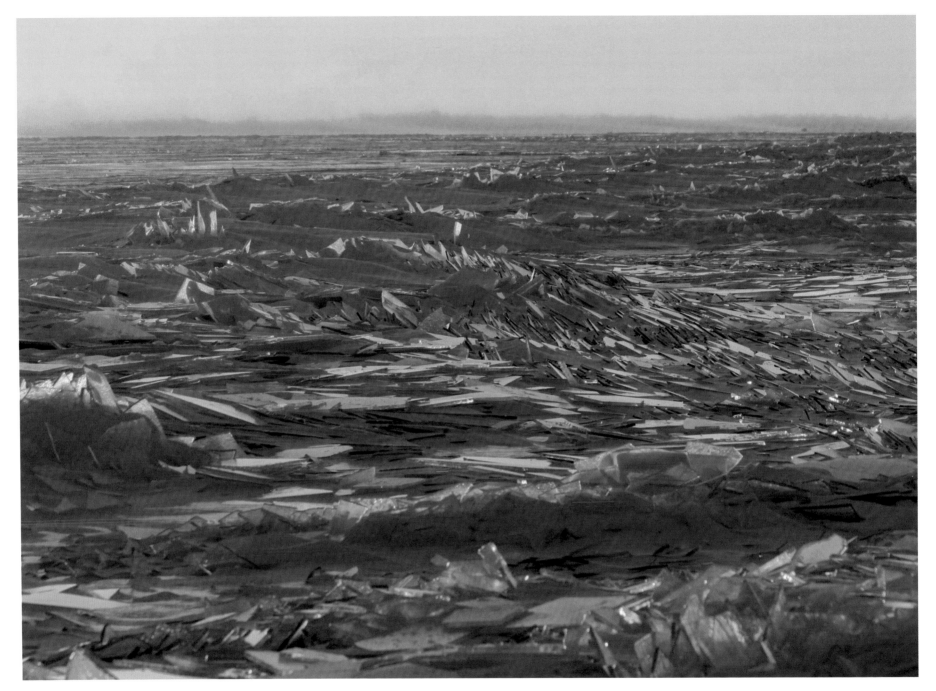

When Time Stops

Like a breath of fresh air, the temperature drops to thirty degrees below zero.

January 31, 2019 8:46 AM, 95 mm

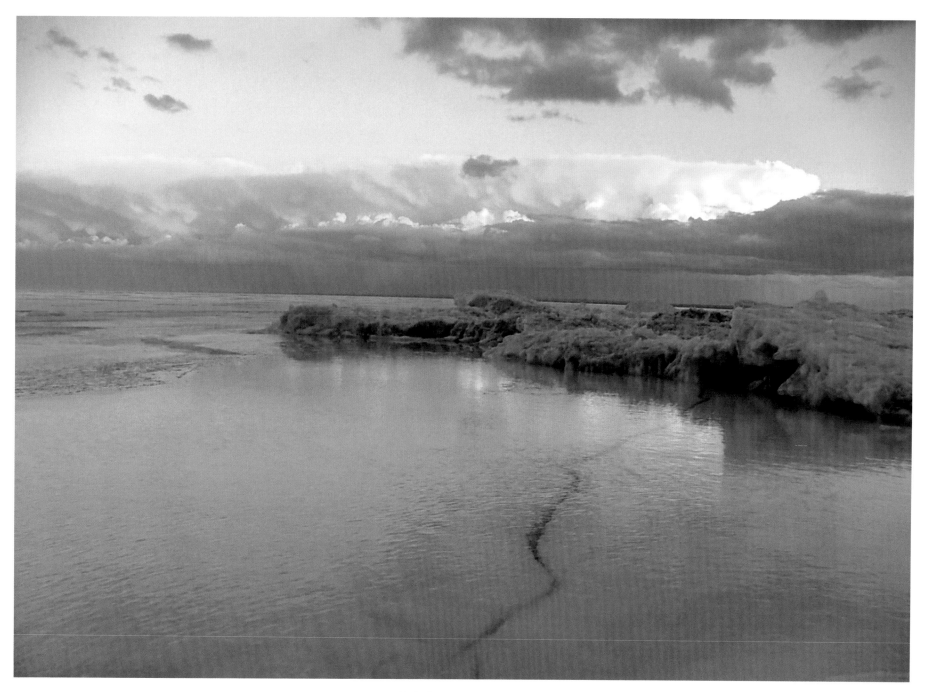

Pristine Winter Light
Early morning soft-hued light freshens placid water above a crack in the winter ice.

February 21, 2006, 7:31 AM, 5.7 mm

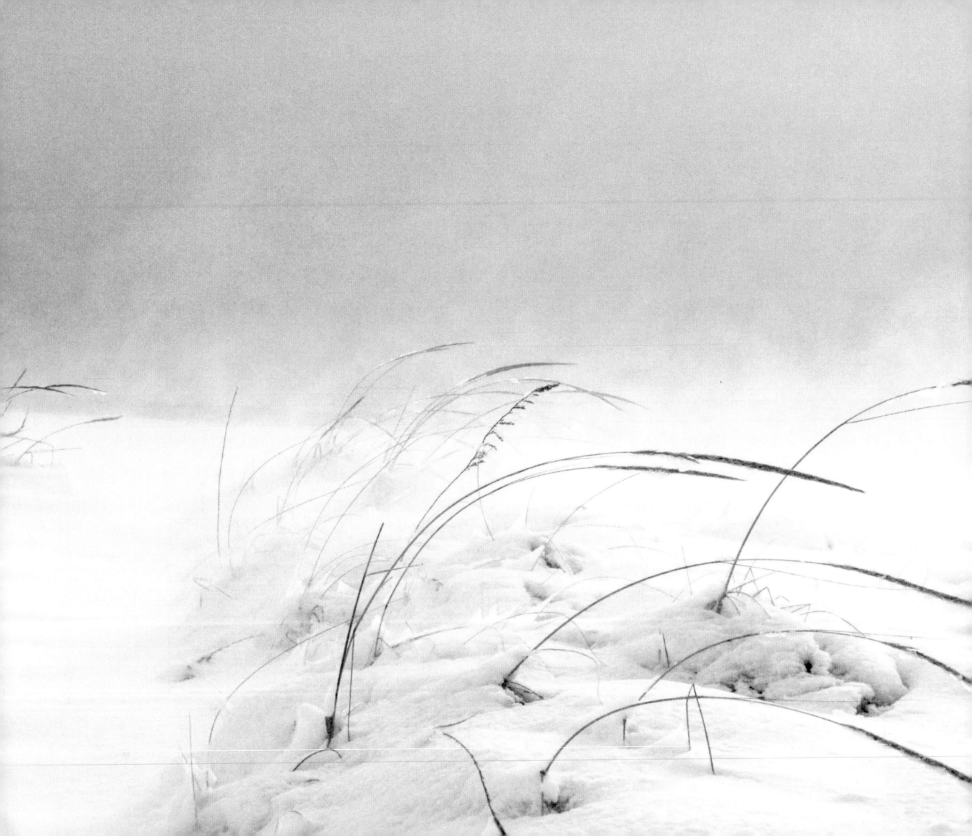

Spring

The lake in spring is moody; she's unpredictable. She is at different times happy or sad, gloomy or bright, stormy or calm, grey or gold, warm or cold. Embracing spring fully is to bring to the beach a swimming suit as well as a heavy jacket, hat, and gloves. When I think of an ideal spring day, I think of opal shades of blue and pink splashed across an endless sheet of snow-covered ice. This juxtaposition of cool colors is cast in a setting of calm skies, mild temperatures, and fresh air. At times like this the lake is radiant.

More often, spring days are characterized by overcast skies, cold winds, and somber colors. These are chilly conditions for walking along the lake shore, but such forays have their rewards. You realize, upon close observation, that the various grays are strikingly beautiful. They provide a perfect backdrop for black and white images of majestic light patterns on the ice or water. Such conditions emphasize the horizon line that extends across the entire field of view— sometimes white, sometimes black, and sometimes only a faintly visible gray line dividing sky and lake. I marvel at the many ways the horizon line can frame the lake. I ask myself, does it do so in halves, in thirds? If so, which is the larger, the sky or the lake?

It would be a mistake to become complacent in spring when warm temperatures, temperate lake colors, and open water arrive. In a matter of hours, conditions can return to winter! Change starts when northeast winds bring sheets of ice, which have long since blown out on the lake, back to shore. Ice approaches the shoreline as the leading edge of a spring blizzard. Howling winds deposit fresh, heavy snow on ice and land. When the easterly winds whip up the new snow, whiteout conditions can occur. This blowing snow has one place to settle and that is on Park Point; the narrow strip of land acts as an enormous snow fence.

A blizzard occurred in early March 1985 when, according to Duluth news reports, "A steady 80 to 85 mph wind with gusts over 90 mph were measured at the Aerial Lift Bridge in Duluth. Snow drifts in Duluth exceeded 20 feet and Park Point remained isolated for almost 4 days." Whiteout conditions obscured the lake ice, and snowdrifts obliterated the single road that connects homes along the length of Park Point.

But at other times, spring's capricious persona manifests itself in calm winds and outbursts of bright colors ranging from multiple shades of red to radiant hues of gold. Yes, the lake sometimes emits a golden radiance, as if lit up by underwater lamps. When seeing this dramatic effect, I feel a profound appreciation for its value. Lake Superior is the largest reservoir of fresh, clean water in the world. This resource is appropriately called liquid gold.

Spring is a season of extremes of color, wind, temperature, ice and waves. It strikes me as the most temperamental of the seasons along the lake shore. Scientists from the Large Lakes Observatory advise people living along Lake Superior coastal areas to expect "more frequent and intense storms and climate variability" resulting from global warming. I am concerned. How will Park Point withstand the even stronger storms of the future?

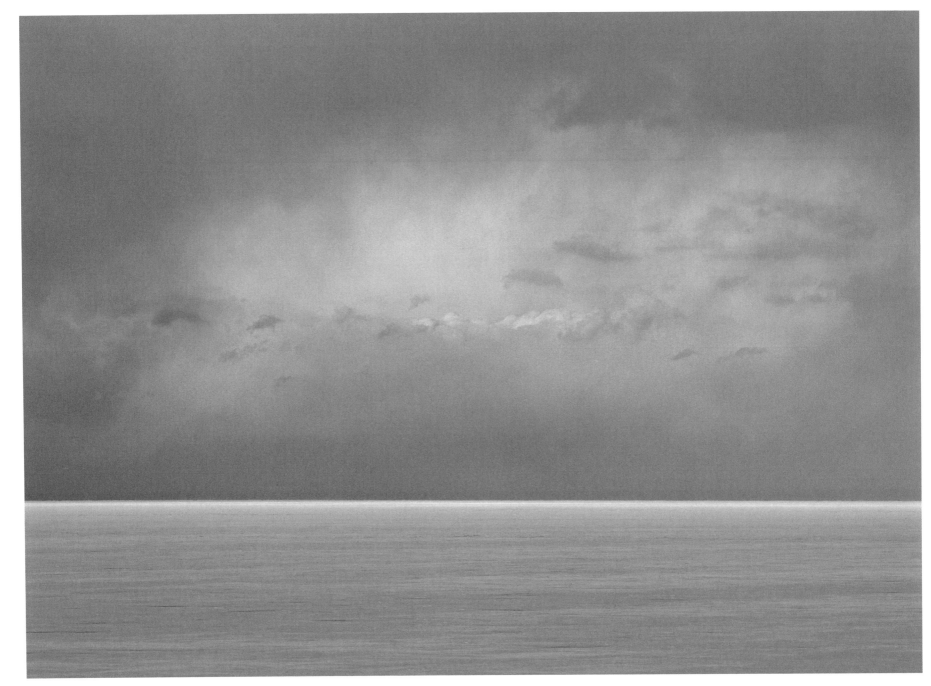

Opalescent

Ice lingers under warm opalescent skies, foretelling spring.

March 24, 2014, 6:50 PM, 100 mm

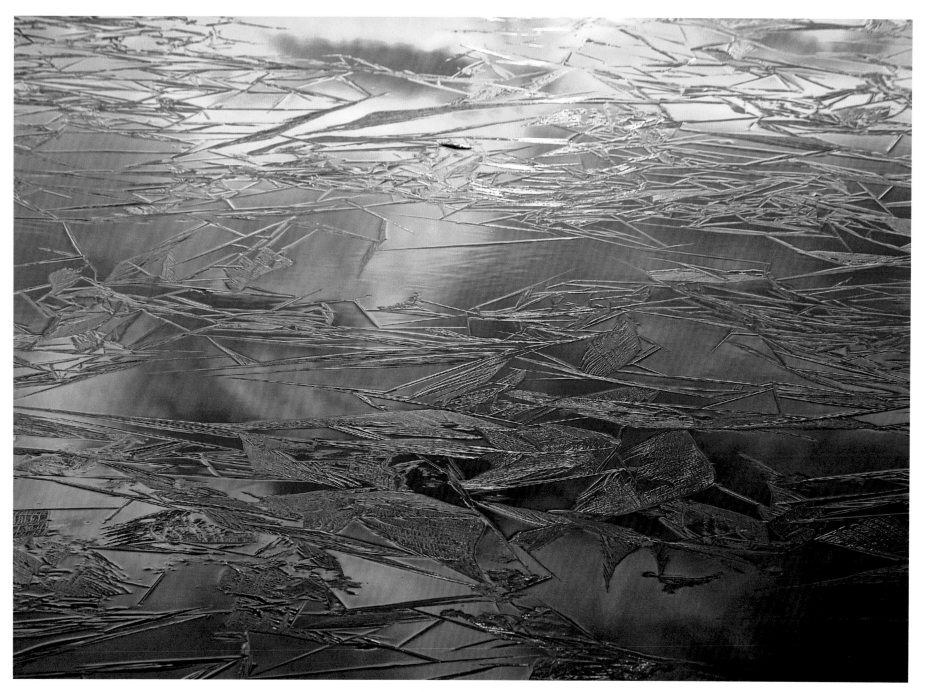

Silver Lattice

Lake is calm as silence. Air temperatures dip into the teens as new ice forms in a luminescent lattice of clouds.

May 11, 2014, 6:31 AM, 100 mm

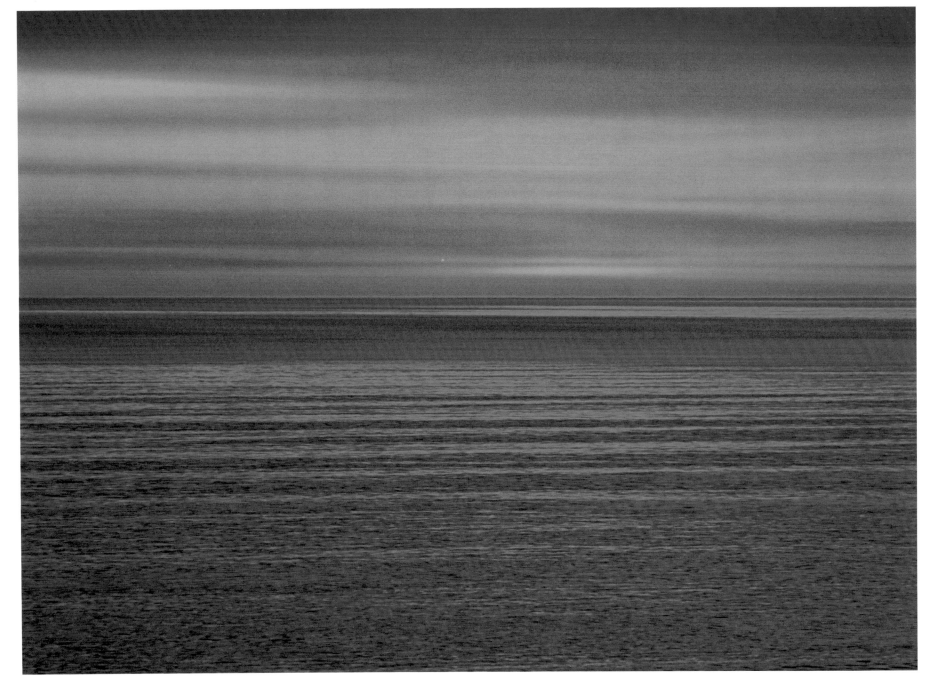

April's Brilliance

In the same month as sub-zero temperatures and blizzards, she is ablaze, as if dressed to greet blooming crocus flowers.

April 5, 2016, 6:30 AM, 109 mm

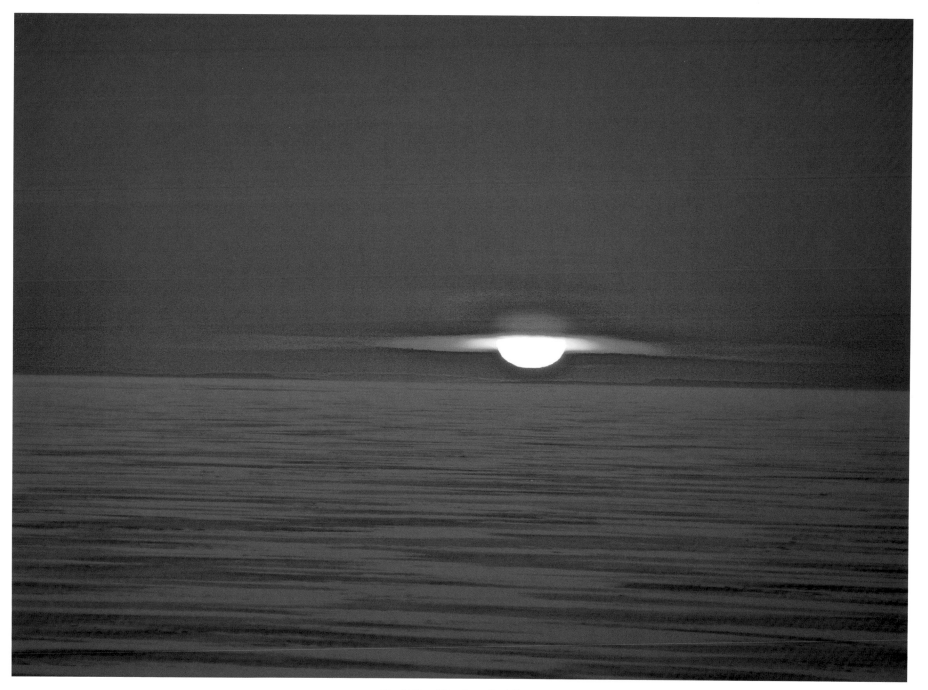

Red Eye Playing the Blues

Ice-covered lake is frosted with melting March snow. The sun makes a brief showing, skipping light like a flat stone on water.

March 21, 2014, 7:19 AM, 171 mm

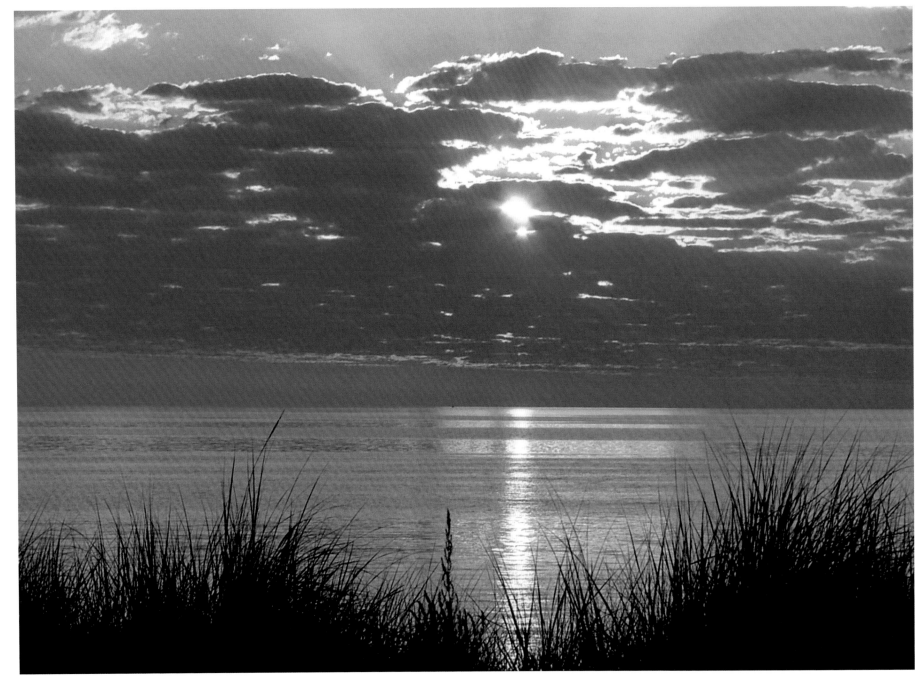

Dune Grass

Dune grass welcomes the sun knowing in its deep roots spring winds will rage.

April 27, 2007, 8:04 AM, 22 mm

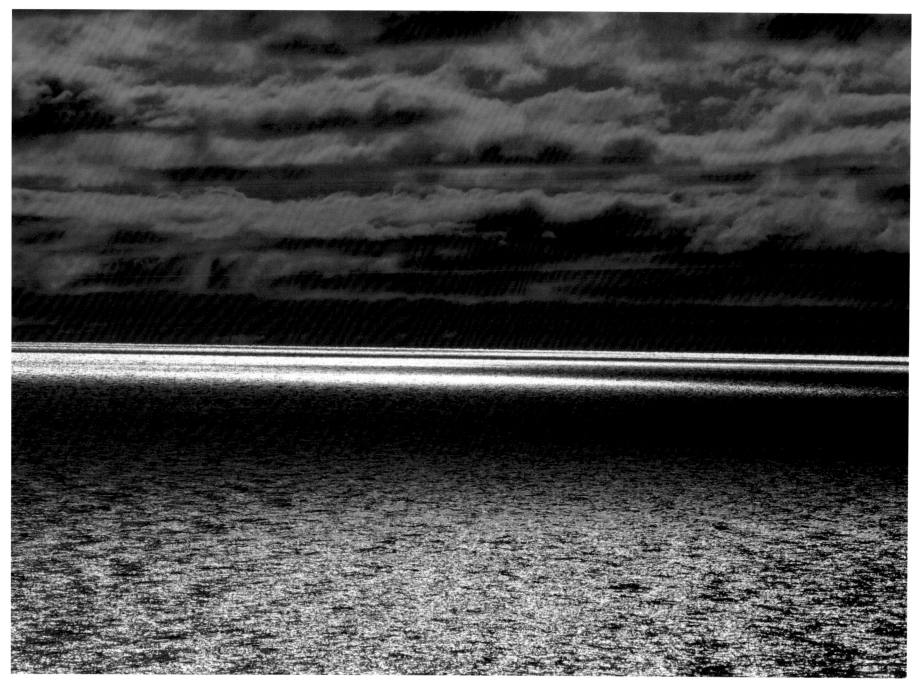

Black, White, Gray

How does she do it? The same sun, the same lake, the same sky; one moment golden, the next dancing blacks, whites, and grays.

June 12, 2012, 7:16 AM, 194 mm

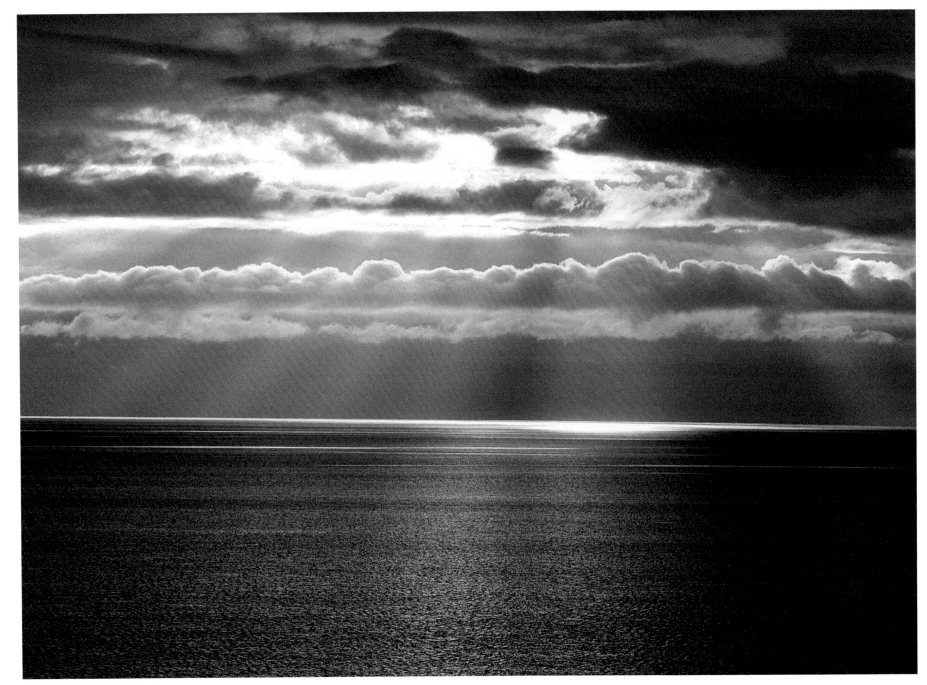

Dances on Water

Dancing rays of light transform slate-colored water.

June 28, 2010, 6:03 AM, 90 mm

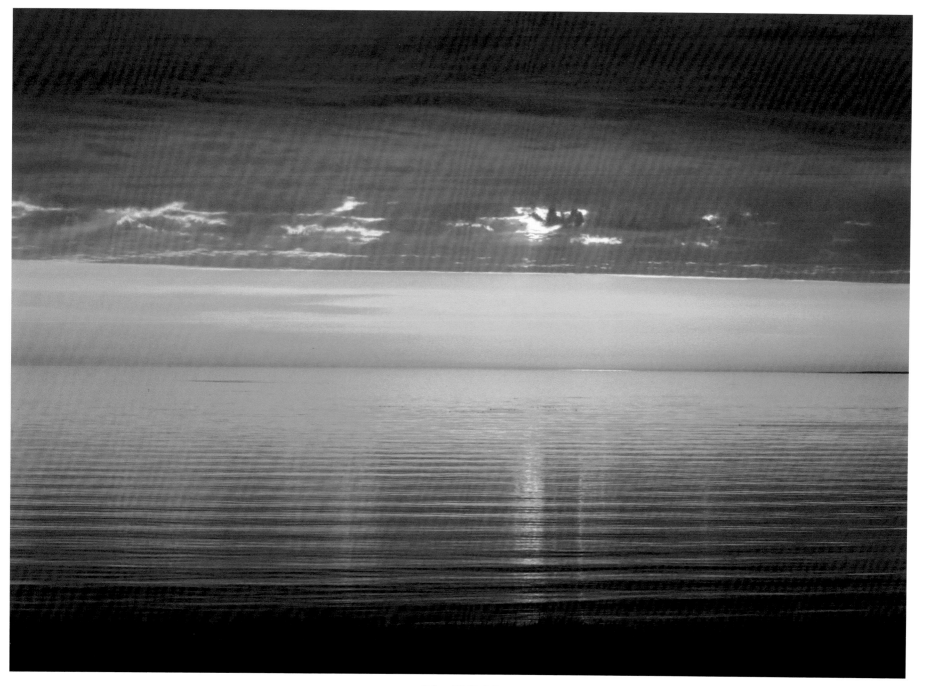

Liquid Gold

Sunlight behind a cloud shows the lake for its true color, glorious gold.

April 24, 2012, 6:45 AM, 55 mm

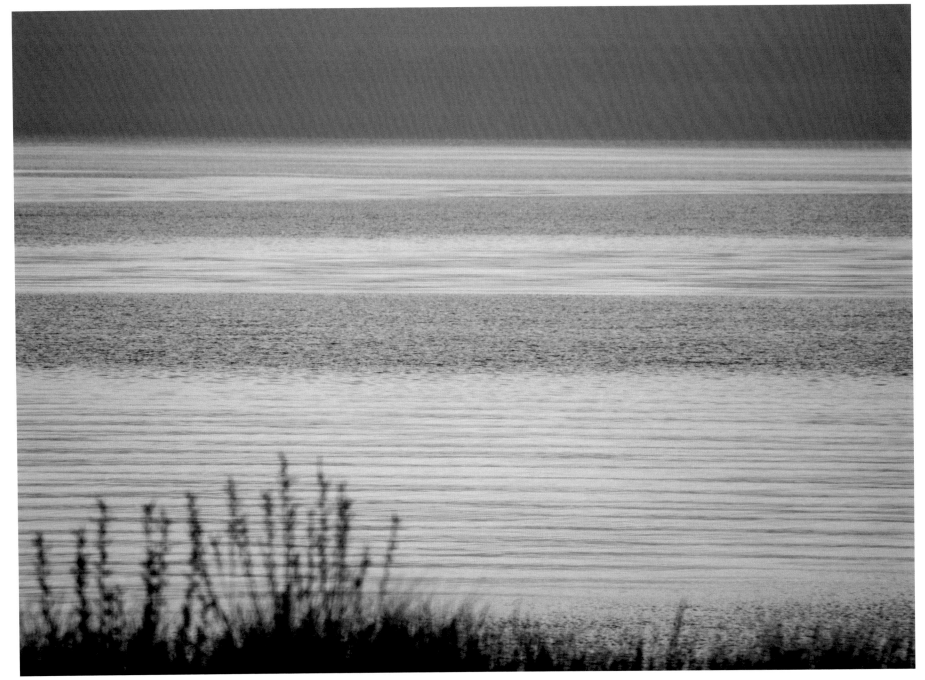

Whispering Wind

Light breezes from the northwest caress the lake, turning peaceful peach-colored ripples blue in the early morning light.

May 10, 2010, 5:17 AM, 250 mm

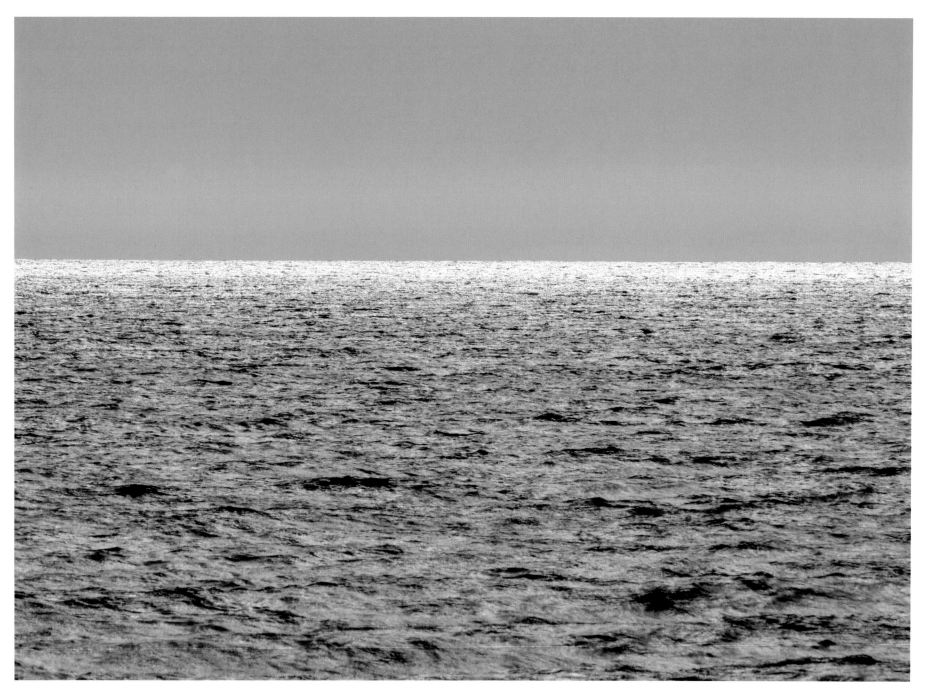

Invitation to Journey

Mesmerizing patterns exert an irresistible pull on my soul, asking what is around the next horizon, like a river bend.

June 14, 2017, 8:06 AM, 250 mm

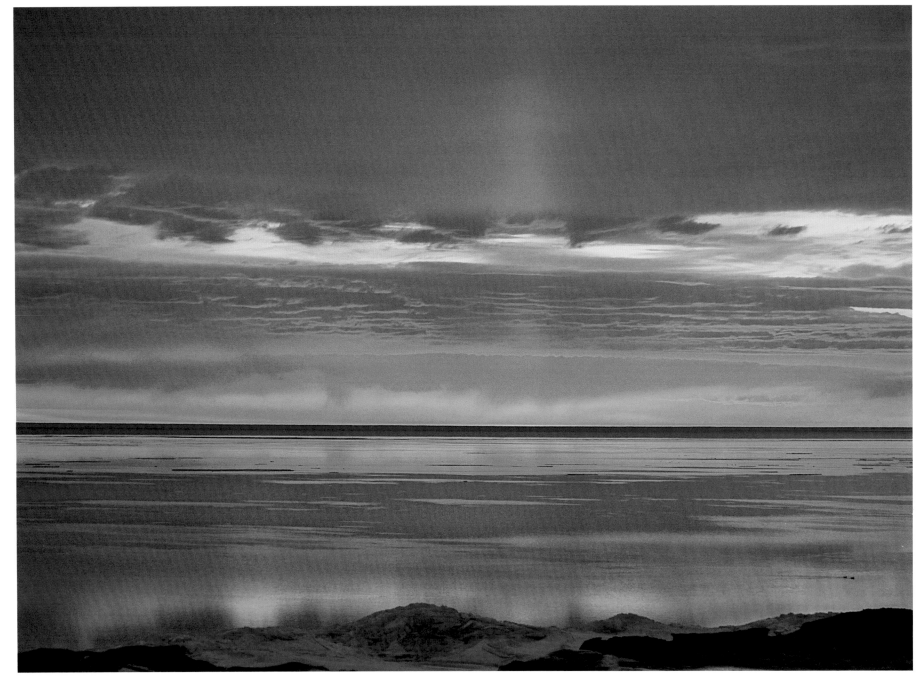

Northern Light

Mimicking the aurora borealis, the sun's rays dance across the sky before dawn.

April 11, 2014, 6:20 AM, 74 mm

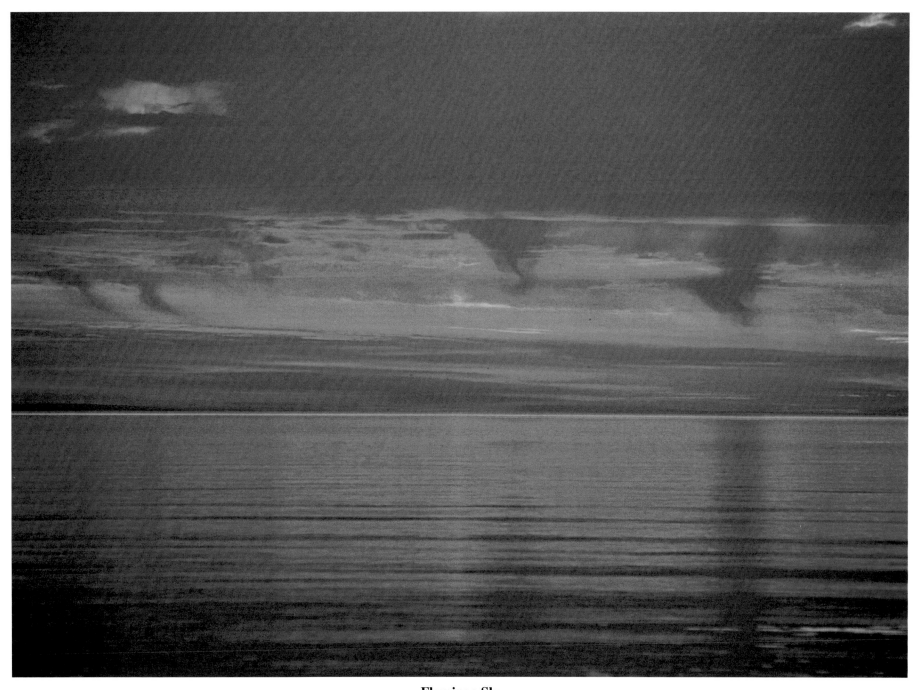

Flamingo Sky

A sighting of Pink Flamingos flaming across the northern Minnesota sky? Is that possible?

June 11, 2015, 4:55 AM, 145 mm

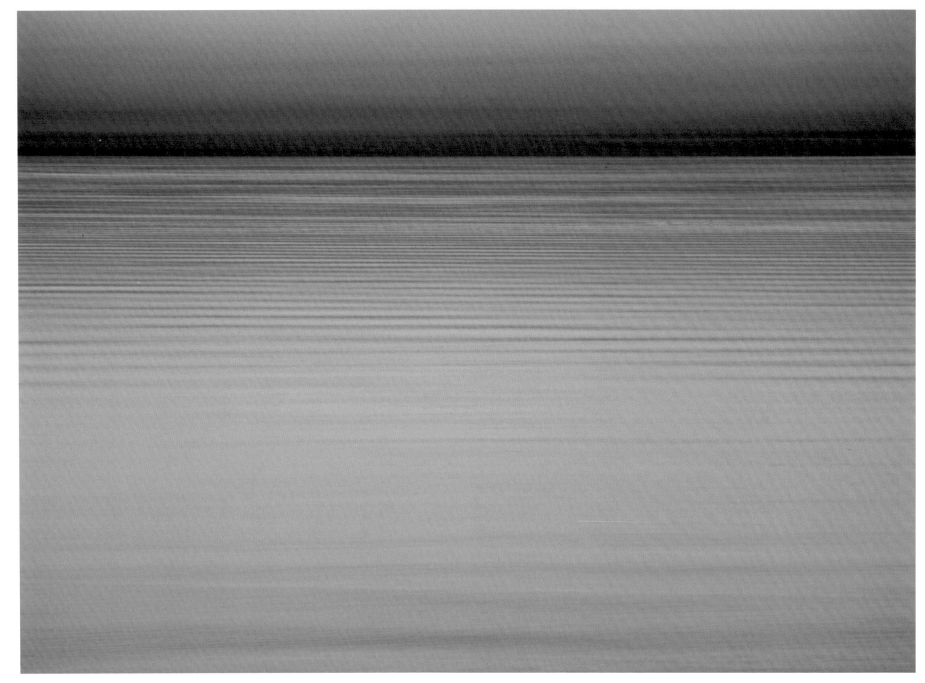

Spring Ahead

Is it an illusion? It is the 4th of May; the lake looks like deep summer.

May 4, 2011, 5:24 AM, 116 mm

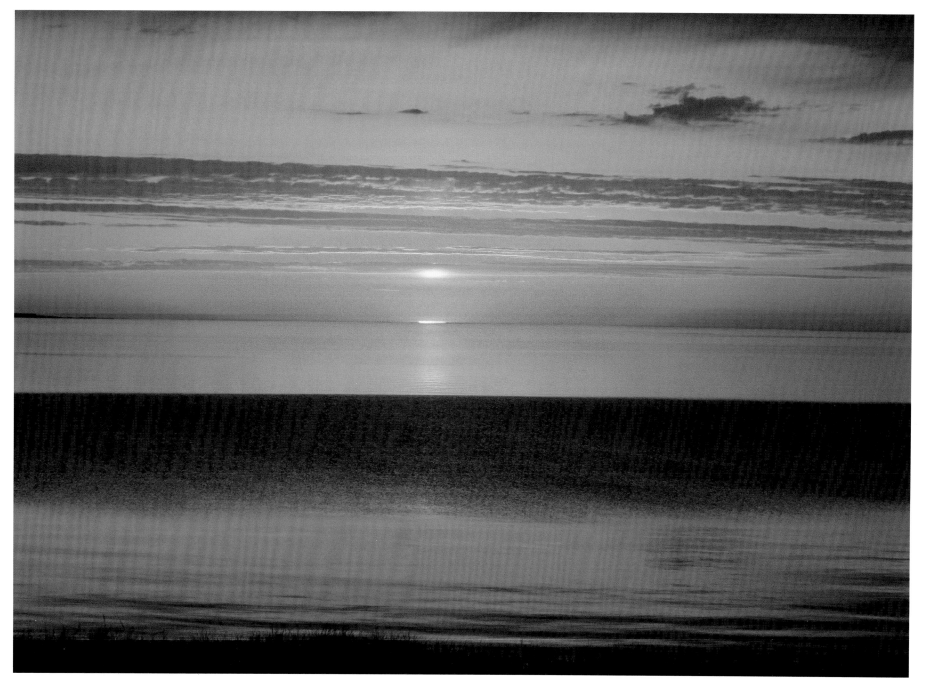

Edge of the Earth

Like a double rainbow, the double horizon line bemuses the savvy sailor.

June 14, 2018, 5:11 AM, 70 mm

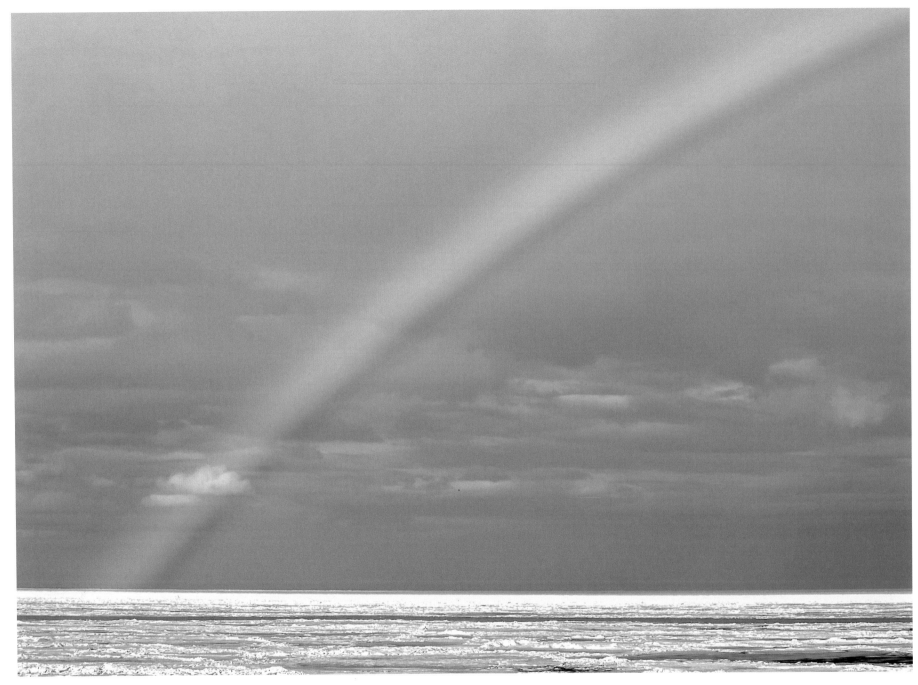

Ice Bow

Gods of the lake playfully plant pots of gold on the fragile spring ice where neither hikers nor casual boaters dare to go.

May 3, 2014, 5:47 AM, 55 mm

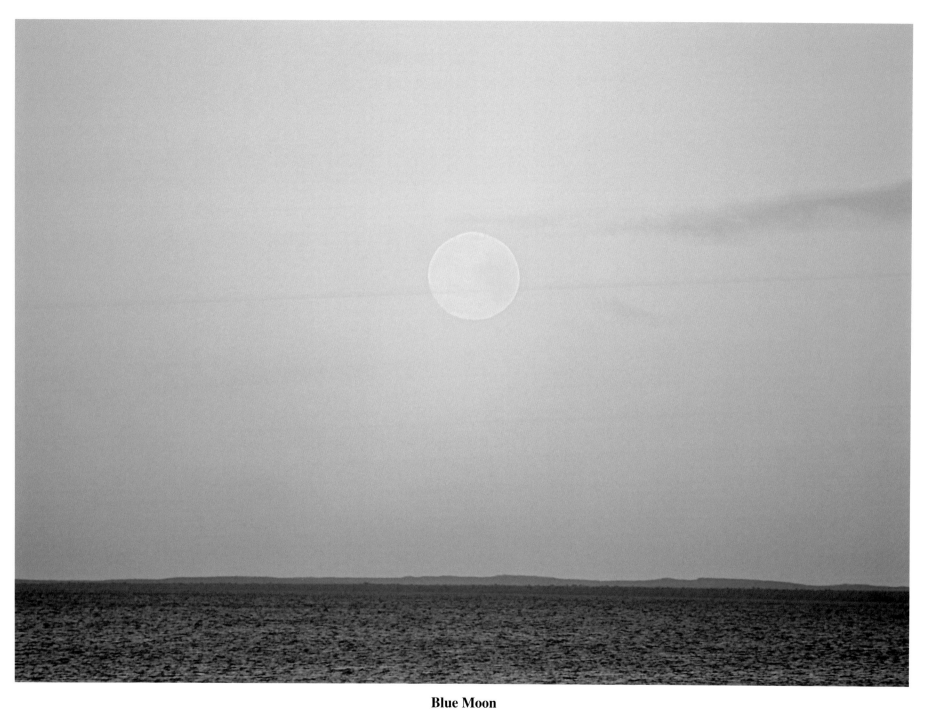

Blue Moon

Bigger than life, the full moon rises over a cold sea of blue.

April 3, 2015, 7:19 PM, 250 mm

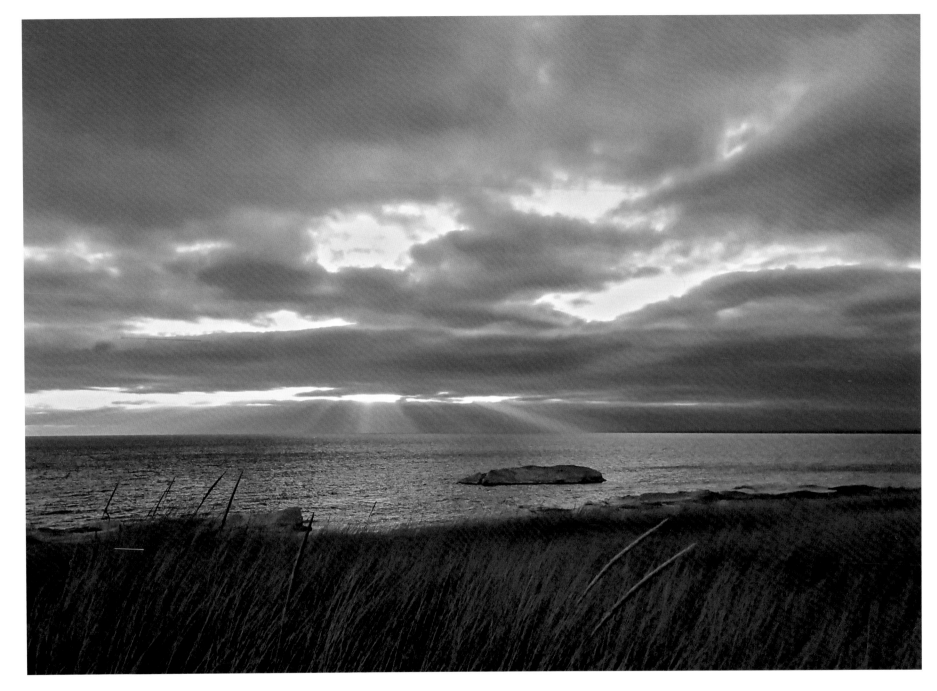

Sowing Seeds

Like a field of wheat, dune grass seed heads stand at the ready for spring harvest.

April 2, 2015, 6:14 AM, 5 mm

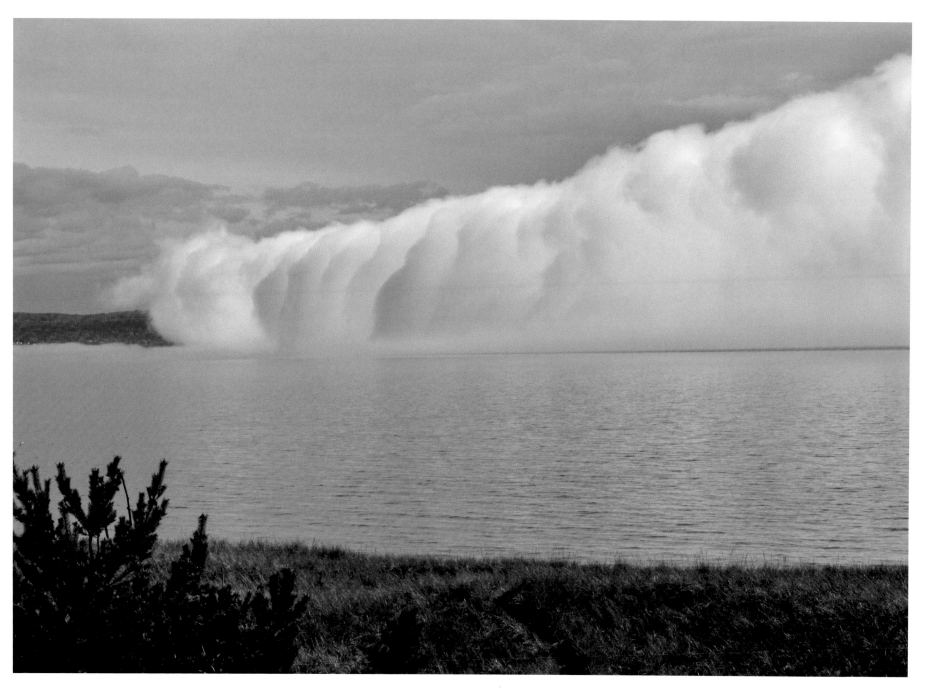

Rolling Cloud

The fog rolls in, turning in the blink of an eye light to dark, warm to cold, and dry to wet.

May 24, 2016, 9:21 AM, 55 mm

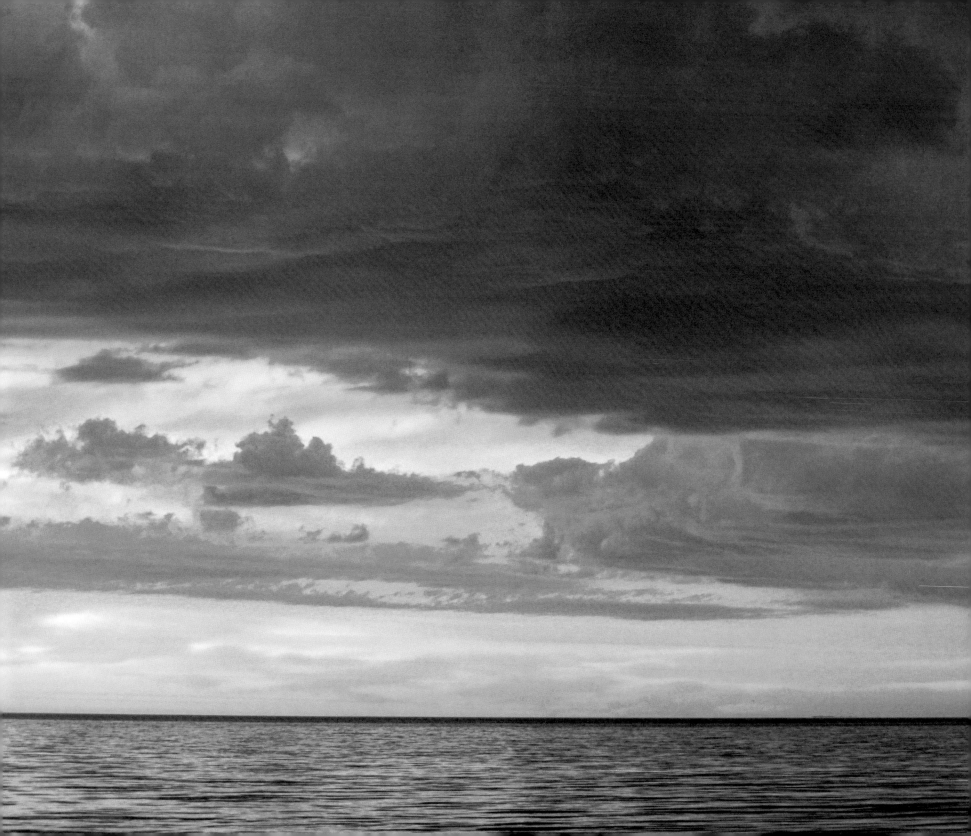

Summer

I associate summer along the lake shore with a brilliant array of light patterns, a rich palette of intense colors, and brief bursts of heat. It's often dazzling, dizzying, burning. For me, a northerner at heart, it can be too bright and too hot. However, summer shows itself wonderfully through indirect means such as reflections of light on the water, spectacular cloud formations, long rolling waves, and cool water temperatures.

Ice that melted months ago cools the water well into July. Children and a few other hardy souls brave the early summer lake temperatures to dip, play, and even swim. The contrast can be exhilarating between the bone-chilling lake water and the warm summer air. At times, when summer winds blow from the south, the air can become hot. Yet these same winds drive warm surface water out into the lake, bringing colder water up to the surface along the shoreline.

One day our family was on the beach seeking relief from unusual heat. The air temperature was 102 degrees. The water temperature hovered around 60 degrees. My son-in-law, a seasoned Lake Superior sailor, yelled to the group, "Here it comes!" We watched as a small patch of dark water hovering on the horizon grew larger. He exclaimed, "Pack up your things!" The wind had shifted, and it was blowing air towards us that had been cooled down by the surface water. Within a half hour we were wearing sweatshirts and long pants.

At the height of summer, more people arrive to play along the lake shore and in the lake. Children evade the hot sand of the paths and sweep quickly through the grasses on their way to the lake, wading into its endless coolness immediately to escape the fiery heat stored in sand. But children aren't the only ones to brave crashing waves. Teams of rowers in narrow shells look pristine, paddling in unison with a discipline and symmetry ideally suited for the lake's early morning calm.

The lake, too, is playful. She comes up on the beach in the summer like a child, sometimes moving sand around in piles, at other times retrieving mounds of sand and returning them to the lake. In its place, she delivers gifts. I have seen everything from children's toys to driftwood and giant logs, deposited on the beach. Recently, a three-foot sturgeon washed up on the beach. The lake toyed with the fish in the surf, as a cat tosses and pounces on a mouse. Her playfulness can be gentle, and it can be wild and turbulent.

There are only a handful of days each summer on Lake Superior that are deemed swimmable. This appears, however, to be changing. Surface water temperatures increased by 3.5 degrees Fahrenheit between 1973 and 2010. This is twice the rate at which average air temperatures increased during the same period! As I gaze out over this enormous body of fresh water, I'm struck by how sensitive and responsive she is to the people who inhabit her shores.

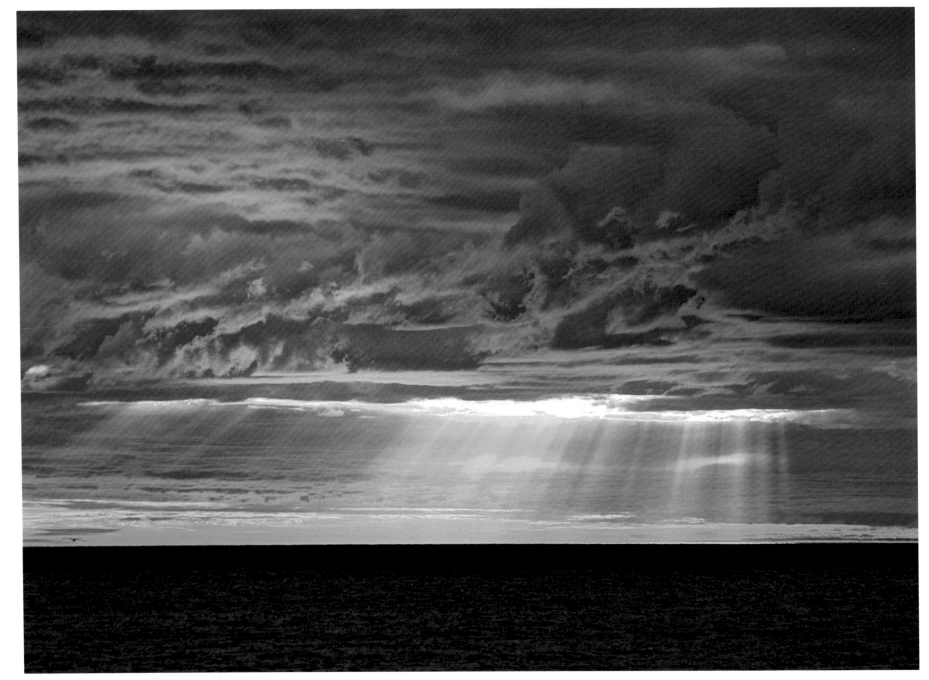

Cool Breeze

A light easterly breeze cools the lakeshore like a fan while clouds above swirl.

July 15, 2014, 6:15 AM, 70 mm

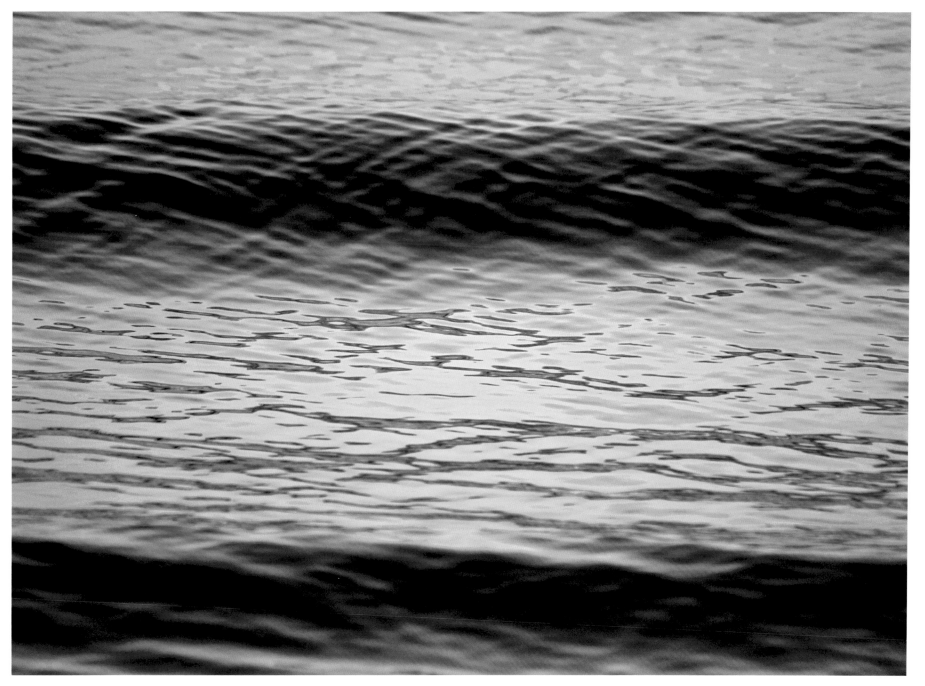

Weaving a Wave

A single wave catches crossing patterns of wind, collecting colors like spilled dye in its trough.

August 5, 2014, 6:04 AM, 250 mm

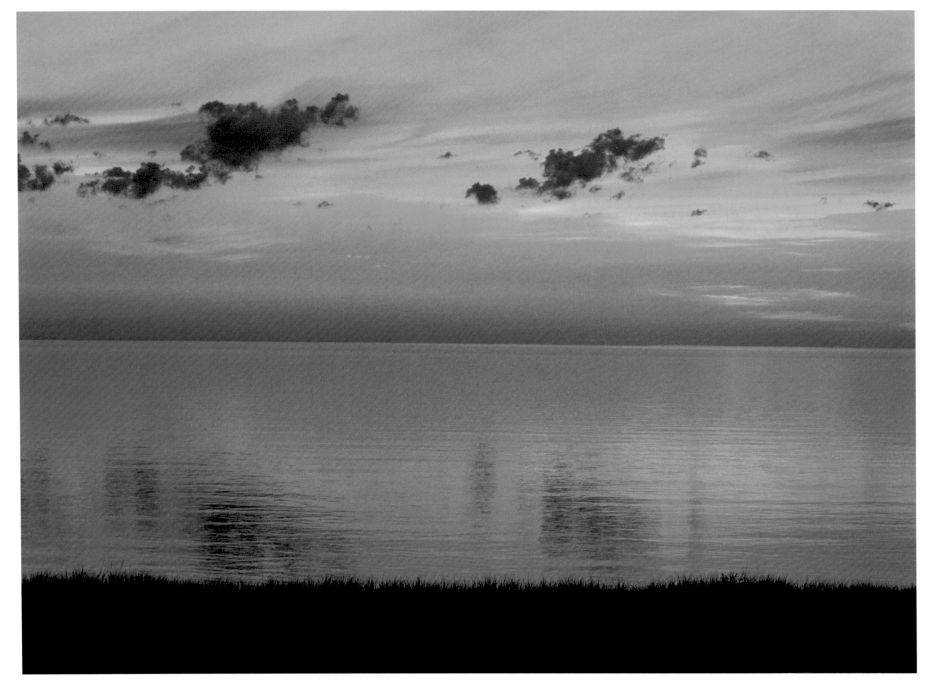

Lingering Night

Patches of darkness across the sky and in the dunes melt in the dawn's early light.

August 21, 2015, 6:02 AM, 55 mm

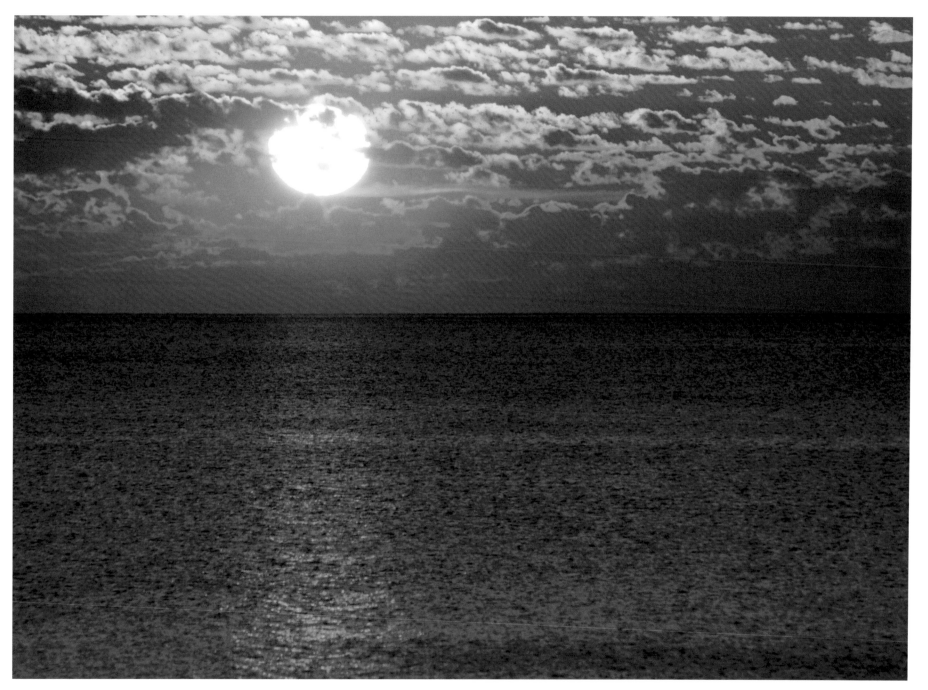

Amazing Grace

As if written in hieroglyphics, a majestic message displayed in the clouds is amplified by tiny waves.

August 12, 2017, 6:10 AM, 250 mm

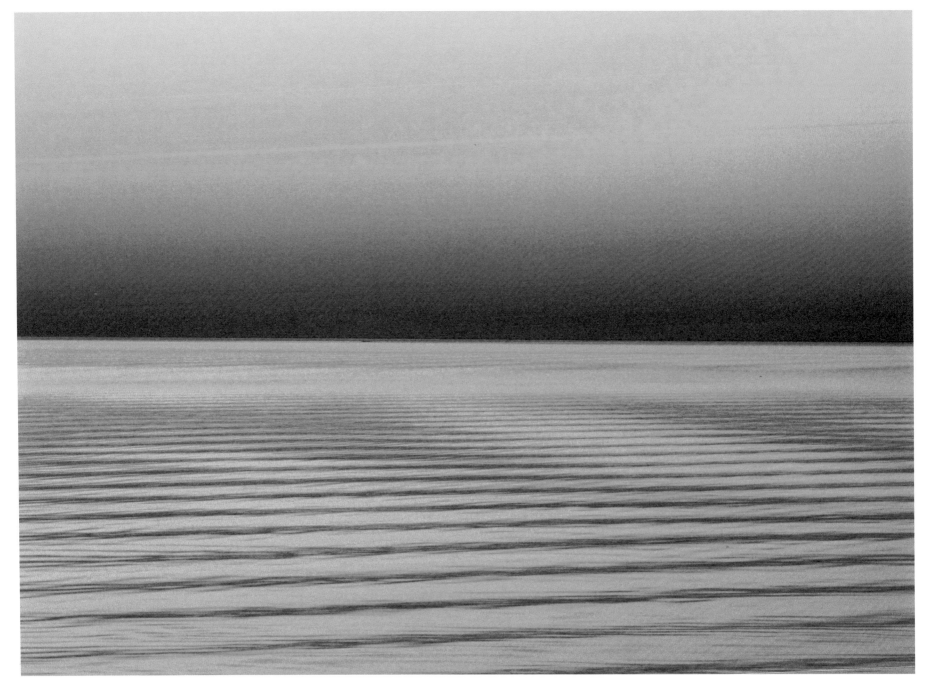

Water Chords
Interplay of wind and water and light plays the lake like a harp, as dawn turns up the volume.

July 25, 2015, 5:41 AM, 116 mm

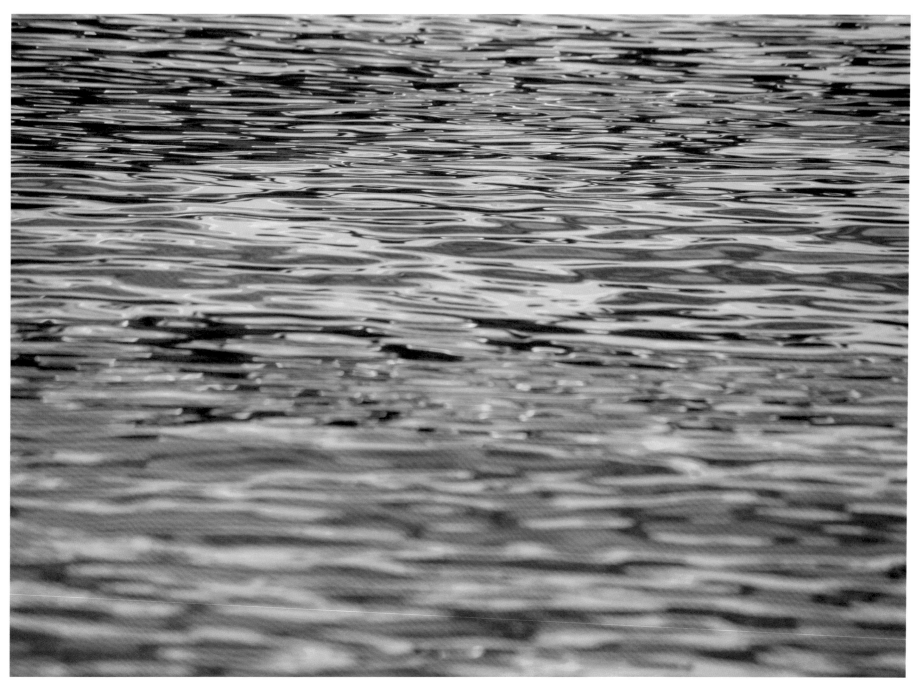

Fresh Water Colors
Artists have a wide palette of aqueous earth tones from which to choose.

August 6, 2017, 6:15 AM, 250 mm

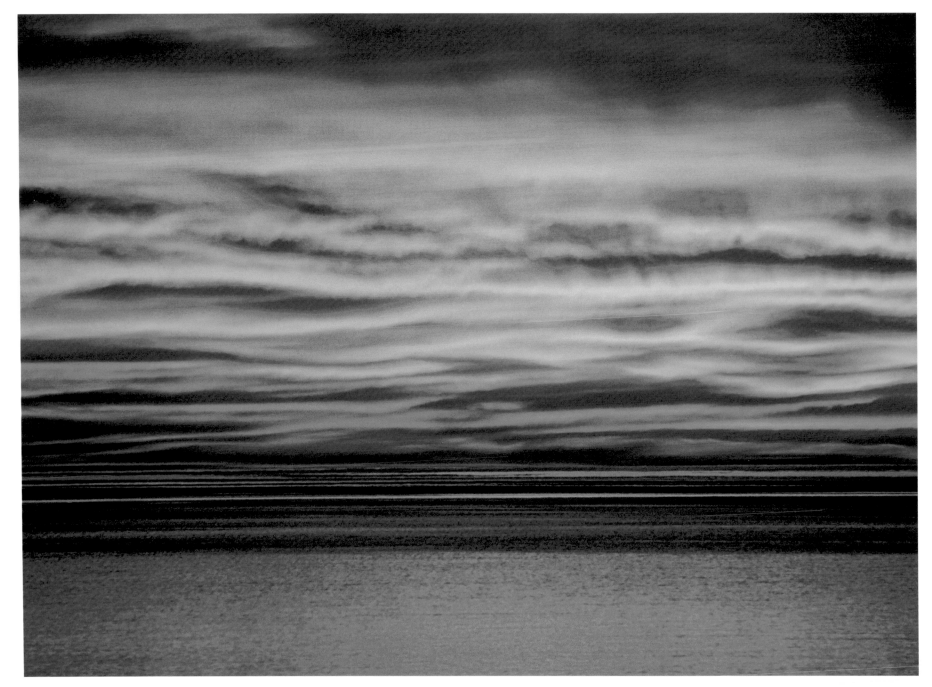

Flowing Clouds

The lake is calm at sunrise, while winds on high channel clouds into waves.

July 23, 2016, 5:21 AM, 187 mm

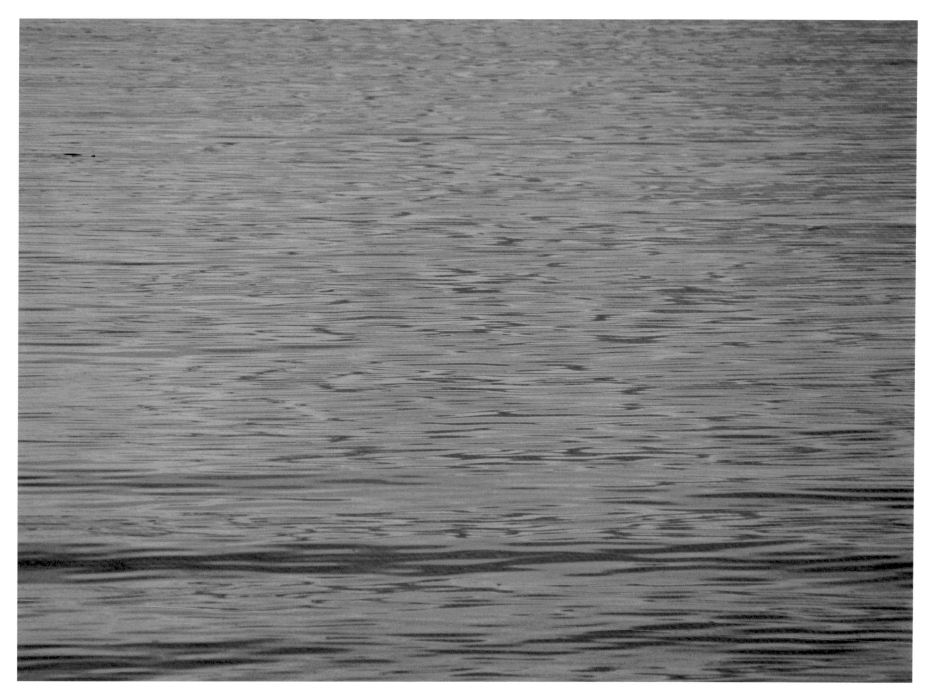

Summer Sweetness

Sun-ripened tomatoes, cucumbers, and carrots are blended into a delicious drink that tastes as fresh as a dip in the lake.

July 23, 2016, 5:27 AM, 229 mm

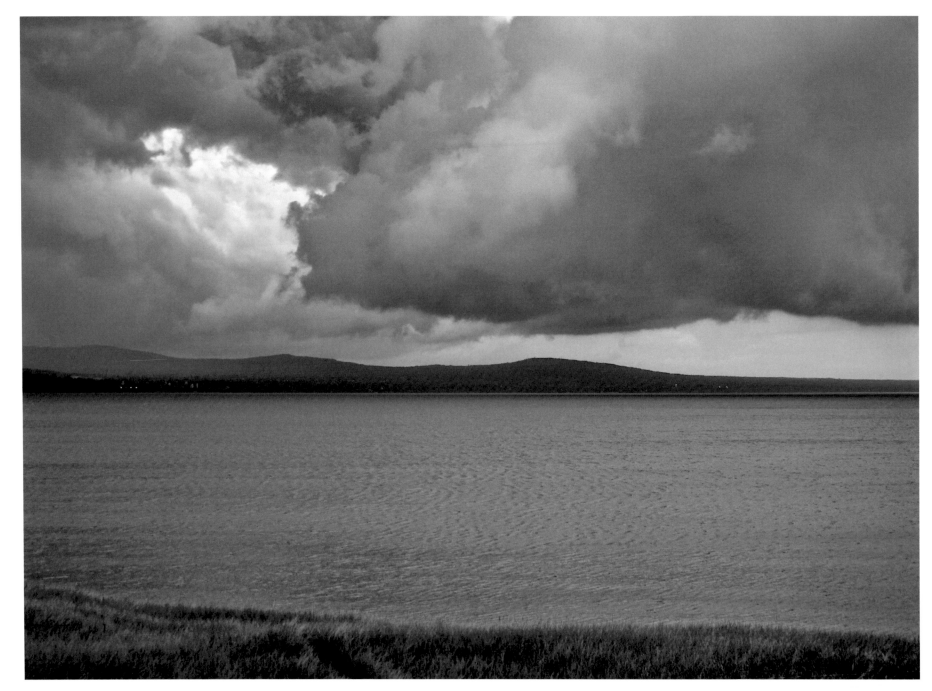

Summer Storm

Ominous clouds build at dusk, preparing to throw lightning darts at elusive fireflies flitting above the water.

September 2, 2010, 7:18 PM, 55 mm

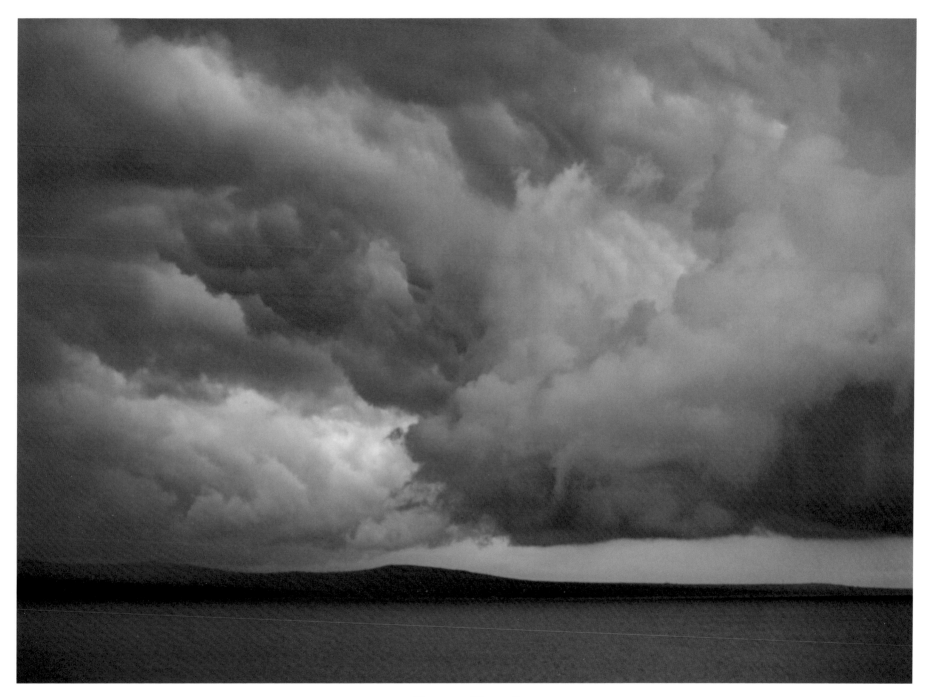

Summer Storm 2

"There is only one thing one needs to know about Lake Superior," a fisherman mused. *"When to get off the lake!"*

September 2, 2010, 7:19 PM, 55 mm

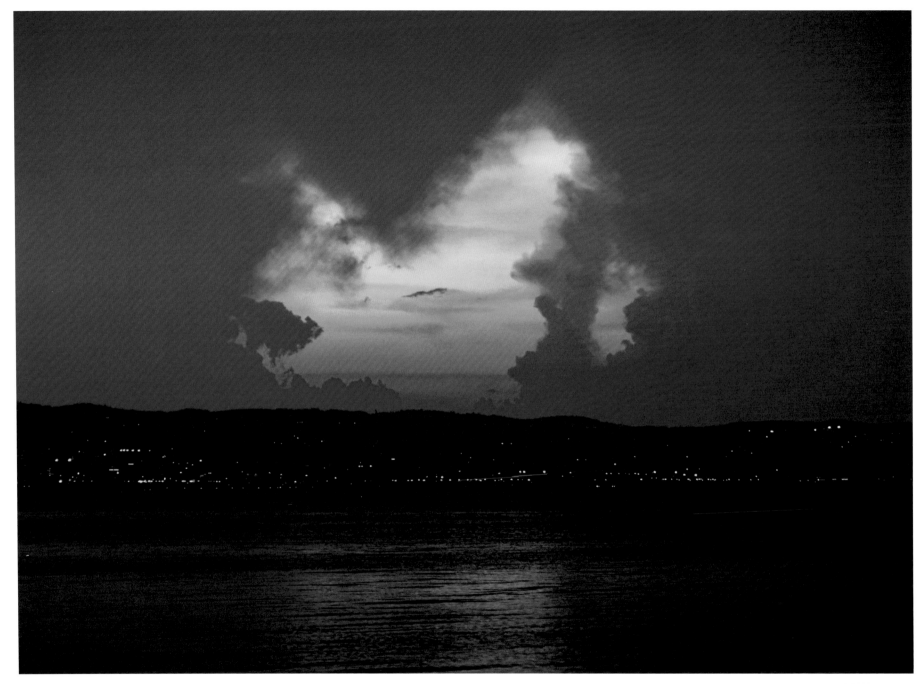

Break In A Summer Storm

The heavens open up at sunset for an instant before nightfall.

July 20, 2012, 9:13 PM, 55 mm

Dawn

An exquisite juxtaposition of complimentary predawn colors is a sight to behold.

August 27, 2012, 6:17 AM, 250 mm

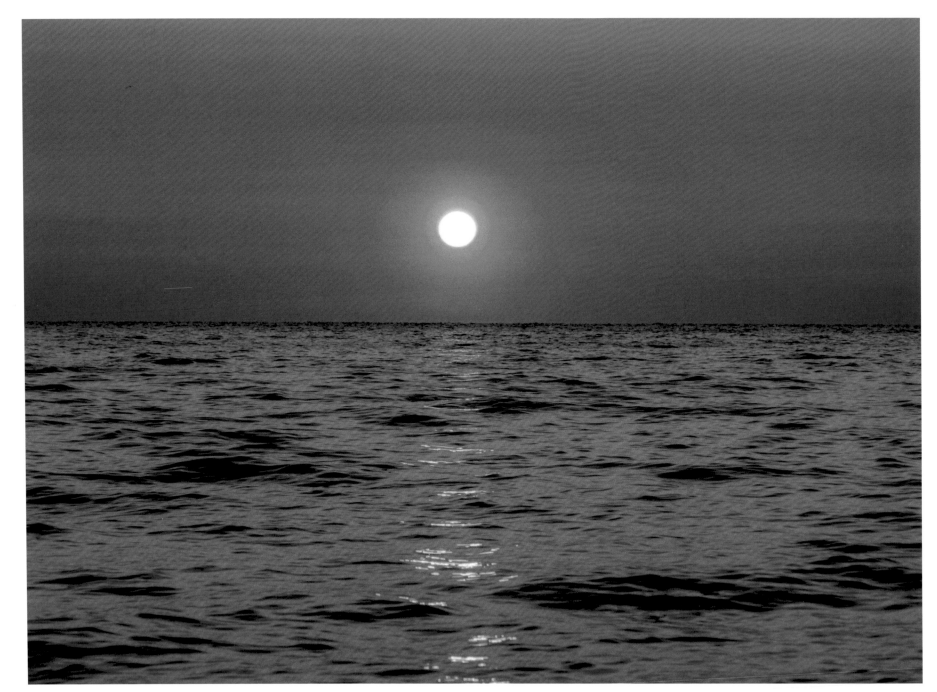

Solitude

The lake cradles light as it comforts a solitary walker on the sandy beach with its lapping waves.

August 25, 2017, 6:30 AM, 90 mm

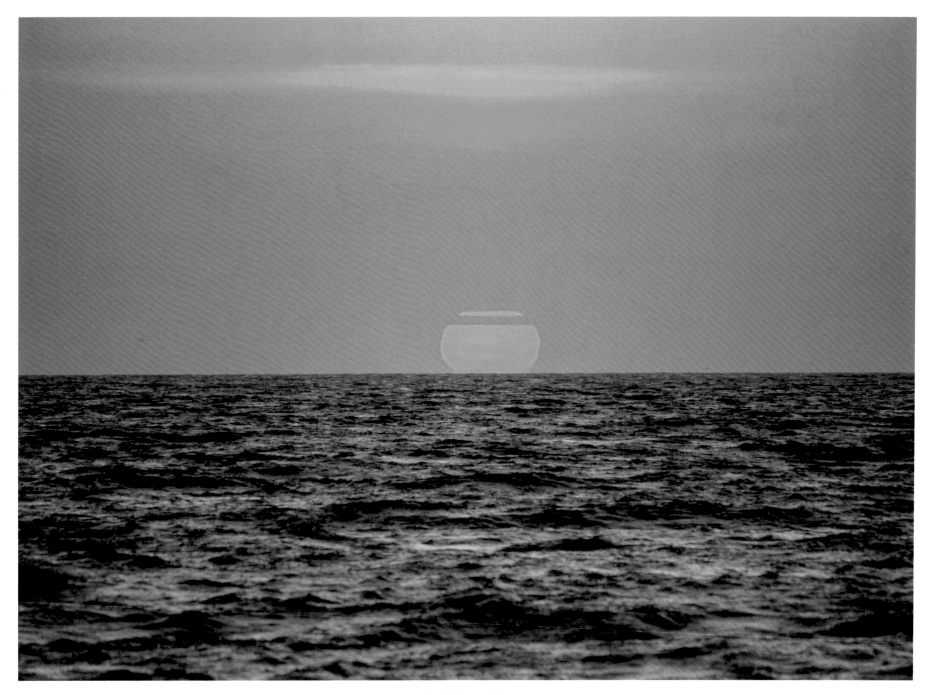

Steel Meets Fire

A cloud pierces the sun. The lake is beginning to cool down in defiance of the sun's warm rays.

September 3, 2017, 6:33 AM, 250 mm

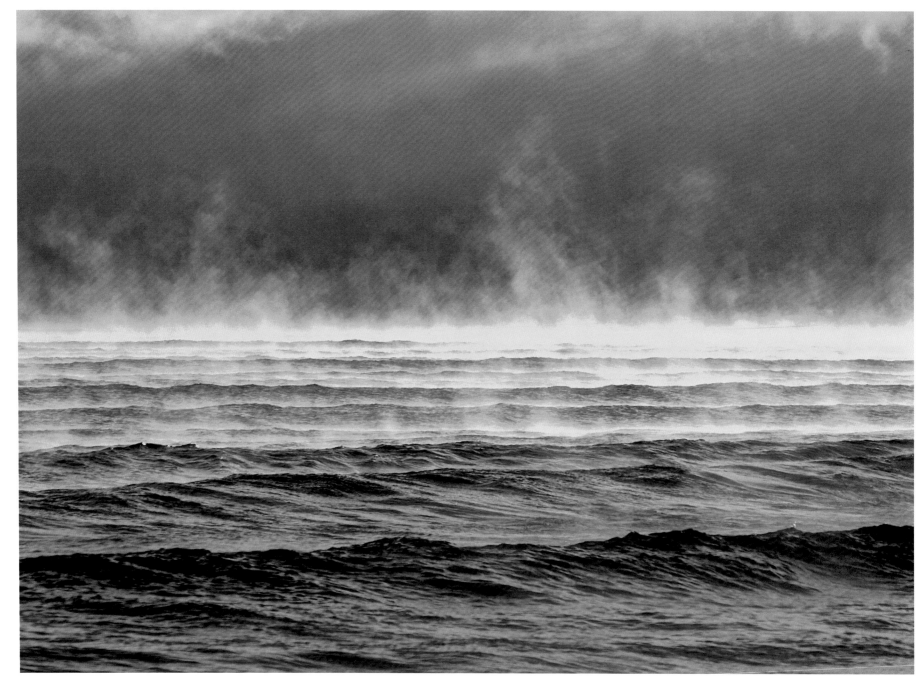

Apparitions

Vapors condense in the chilly air. The stage is set for gods to emerge in an early morning glow.

November 27, 2014, 9:17 AM, 187 mm

82

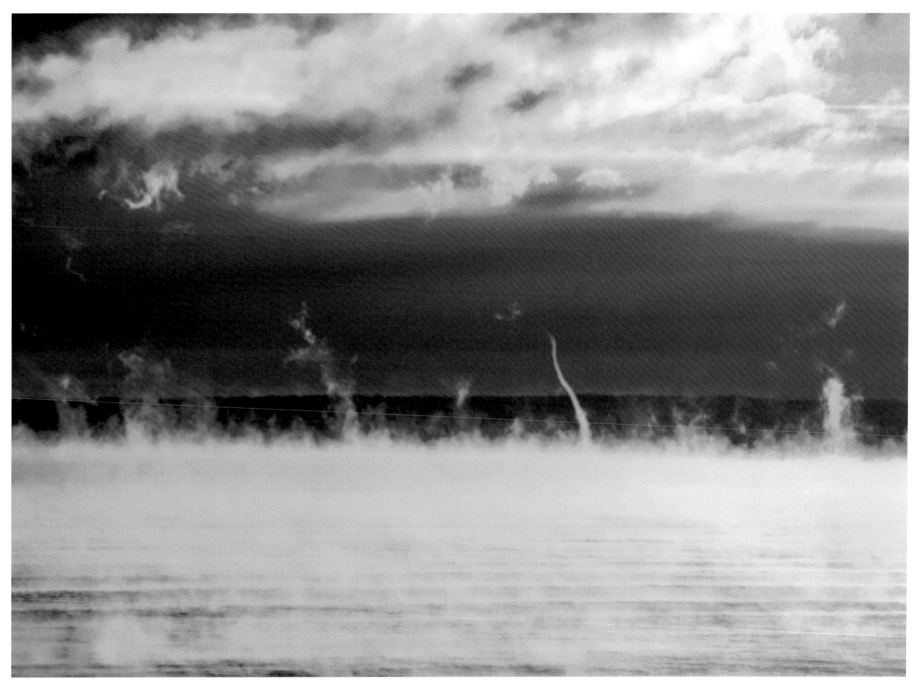

Whirling Dervishes

The Great Transmogrifier: she gives shape to spirits who float and dance above the water.

December 12, 2017, 8:59 AM, 300 mm

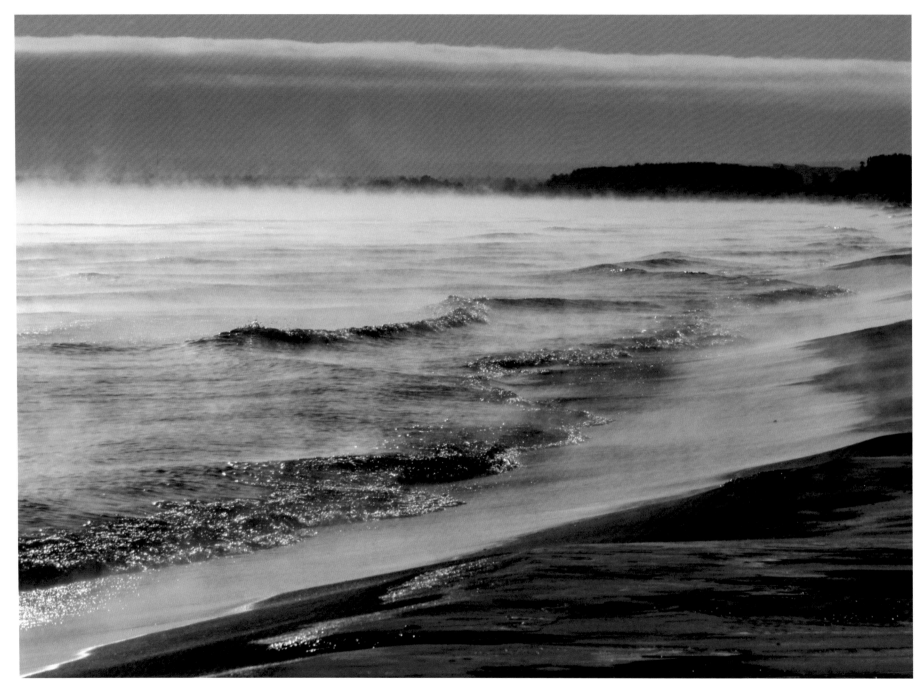

Approaching Shore

Winter rolls in, looks around, and rolls out, preferring to wait for colder air.

November 24, 2012, 9:24 AM, 123 mm

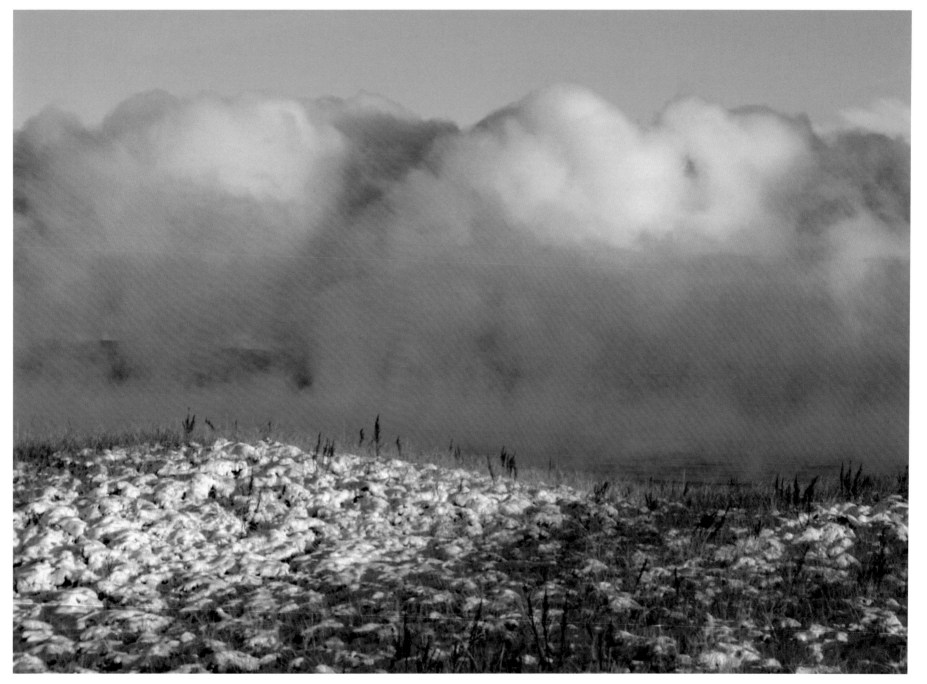

Cloud Bank

Blue skies and snow-covered dunes frame billowy clouds that keep winter at bay.

January 11, 2009, 1:19 PM, 215 mm

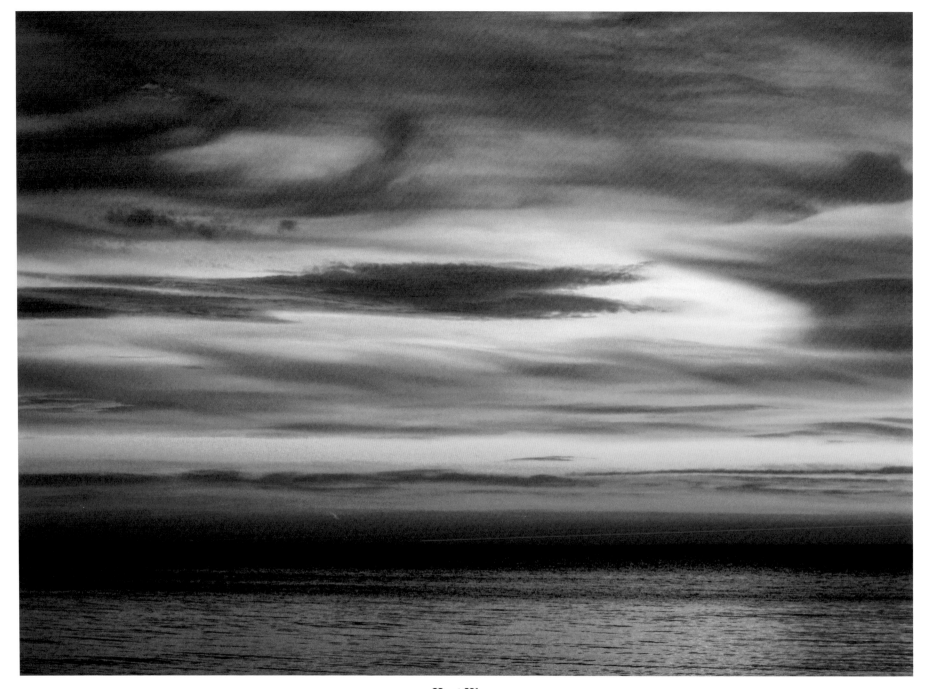

Heat Wave

What in the world! August-like colors and temperatures in December?

December 5, 2015, 8:23 AM, 55 mm

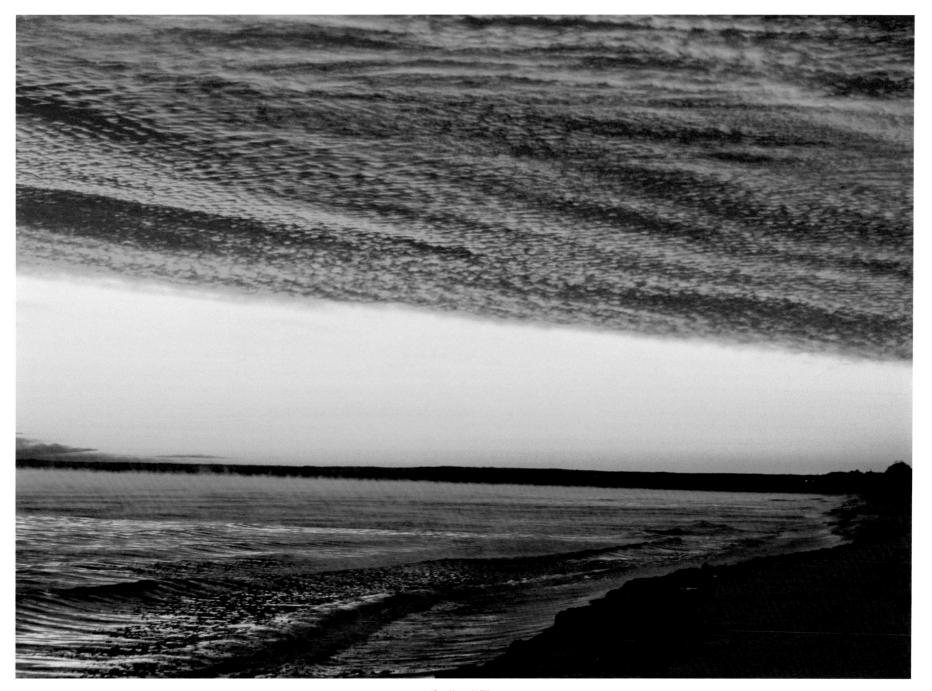

Quilted Sky

Fairies have prepared a quilt, pulling it over a sleepy shoreline for the upcoming winter.

December 12, 2017, 8:37 AM, 70 mm

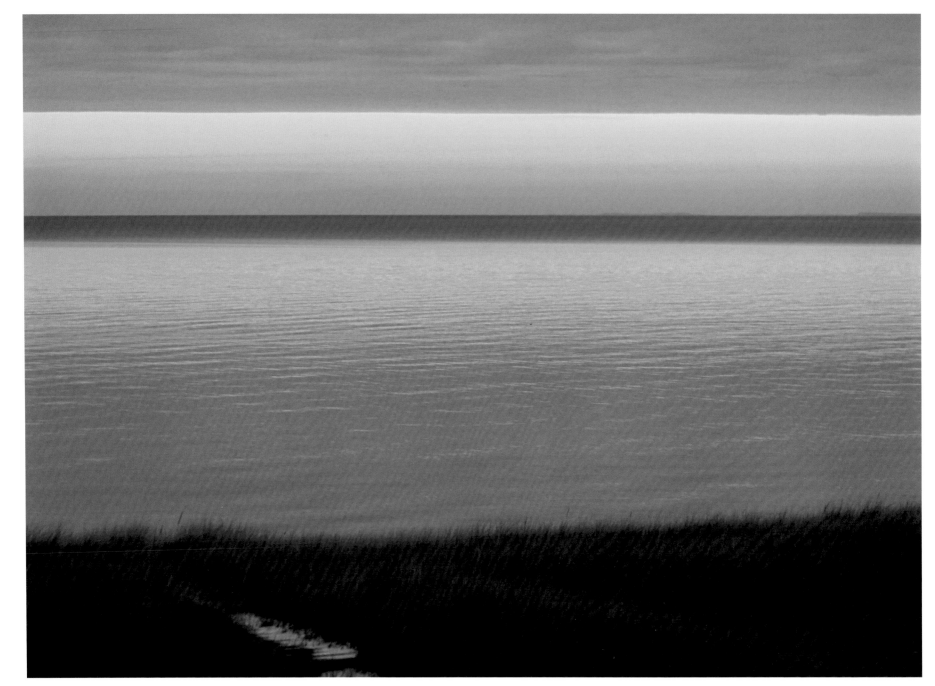

Autumn Blues

The lake, feeling the seasonal blues, would rather be roaring with gales of November laughter.

November 23, 2017, 5:18 PM, 70 mm

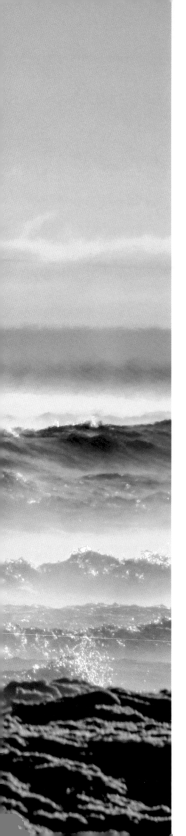

Autumn

At its onset, autumn is characterized by coolness in the morning air that we might mistake for a lake breeze. But this coolness isn't generated over the lake; it's generated over land when frost settles in low-lying areas and then finds its way down to the lake shore and later to the lake itself. Early autumn is as subtle as dew drops on the dune grass. It's as faint as the swirling nighthawks that feast on insects near the lake before beginning their migration. Autumn vacillates with uncertainty between summer sweetness, cool breezes, and volatile weather systems influenced by the differential in lake temperatures.

Some people consider autumn their favorite season because of its rich, varied, and ever changing colors and its dramatic weather extremes. I love autumn along the lake for these and other reasons. The dwindling number of beach walkers suits my solo sensibilities. The patterns of light on the lake are a thing of wonder. The occasional warmth is sweetness on my bare feet. The changing color of the dune grasses is as beautiful as the colorful foliage that maples, oaks, and tamaracks display at this time of year. The storms of autumn can be violent; they excite the sailor in me. And the arrival, by fits and starts, of colder air satisfies my need for seasonal change. I am comforted knowing that winter is on the horizon.

For most of his long life Mr. Pontliana, one of Duluth's premier gardeners, maintained a vegetable garden nestled into the sand dunes on Park Point. His homemade greenhouse was his castle.

Often I would find him there, sitting in a rocking chair next to a wood stove that held off the autumn chill. His gardens were lush with grapes, beans, tomatoes, potatoes, many other vegetables, and flowers. In the face of blowing winds, cool temperatures, and sandy soil, he was able to produce a hearty abundance of food every year. Many of his secrets went to the grave with him. He shared a few of them with me, and I am trying to replicate his successes.

Dune grasses, too, have learned how to thrive in these harsh conditions. The only known Minnesota populations of American beach grass are found along Park Point. They live only in the fore-dunes, areas next to the lake where the wind is the greatest and the conditions are most harsh. The plant adapts to stress through its leaves, which can roll or fold when exposed to excess heat, sunlight, and wind. Like Mr. Pontliana, many Park Pointers, including me, thrive along the lake shore because of the harsh conditions.

Will conditions along Lake Superior become harsher? The answer to this question is an unequivocal yes. Average wind speeds over the lake have been increasing by nearly 5 percent each decade since 1985. Combined with new extremes in lake temperatures and water levels, the conditions are building for increasingly stormy weather out on the lake and along its shores. I'm bracing for the gales of November to grow more fierce in the years ahead.

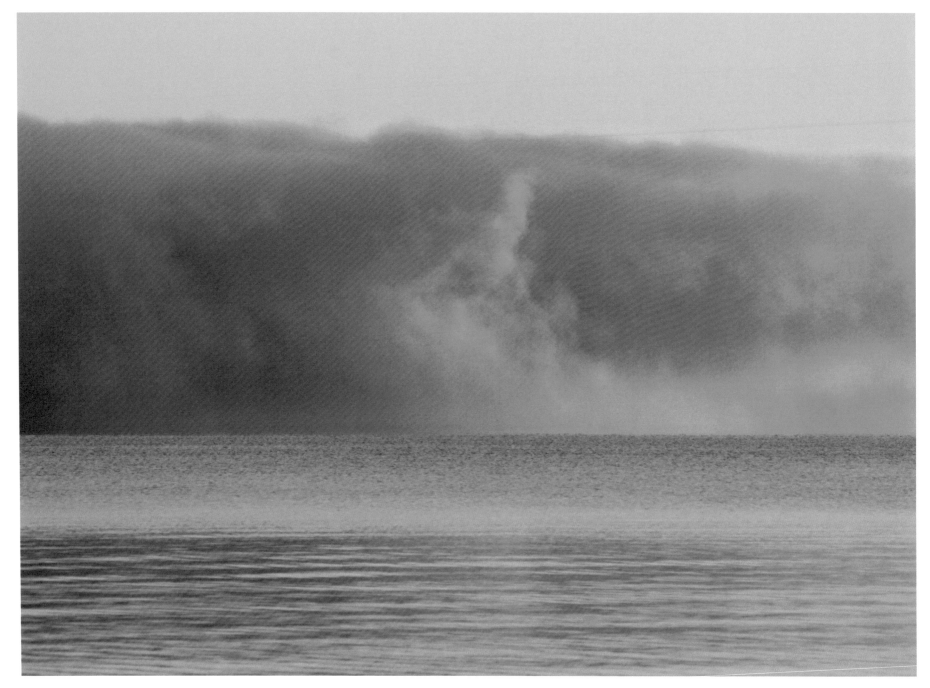

Autumn's First Cloud

Mist, formed by the meeting of warm water and cool air, and backlit by early morning sun, grows to become a bold bank of clouds.

September 18, 2016, 6:59 AM, 171 mm

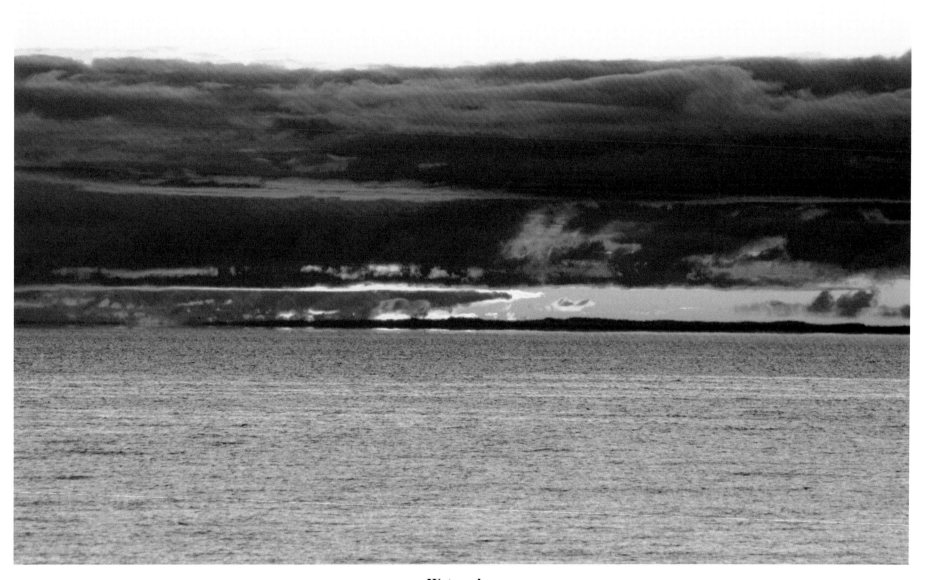

Watercolors

Paint splashed across the clouds drips onto the horizon before it can dry.

October 9, 2016, 7:12 AM, 154 mm

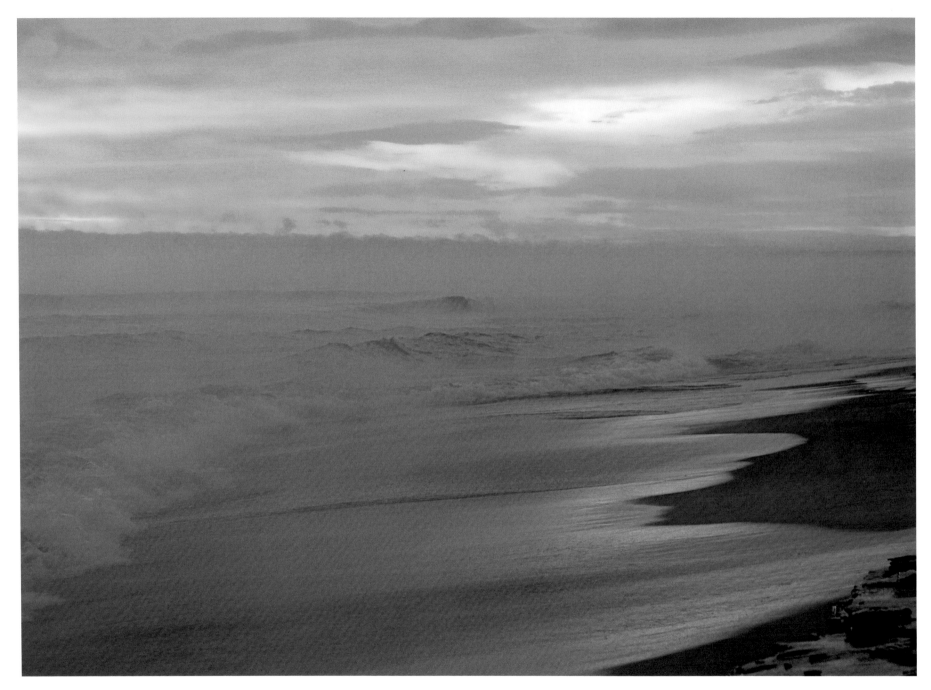

Gift of the Morning Muse

The sun on a chilly November morning lights up the mist with a soft lamp. Cold fingers reach longingly for the beach.

November 29, 2013, 8:26 AM, 55 mm

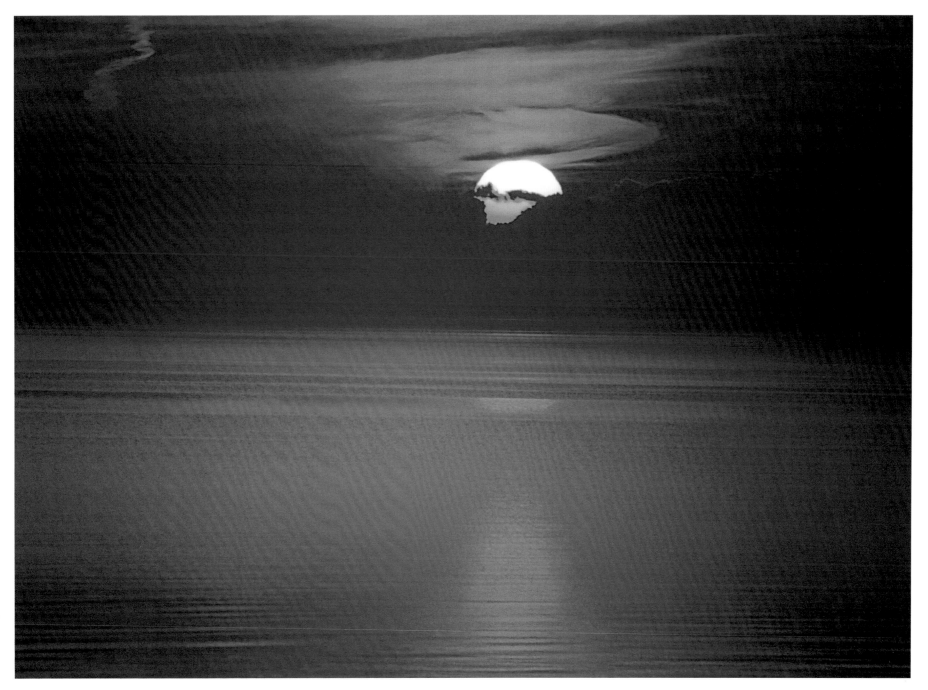

Peek-a-Boo

The September sun casts a copper glow, adding to Autumn's mystique.

September 20, 2014, 7:09 AM, 220 mm

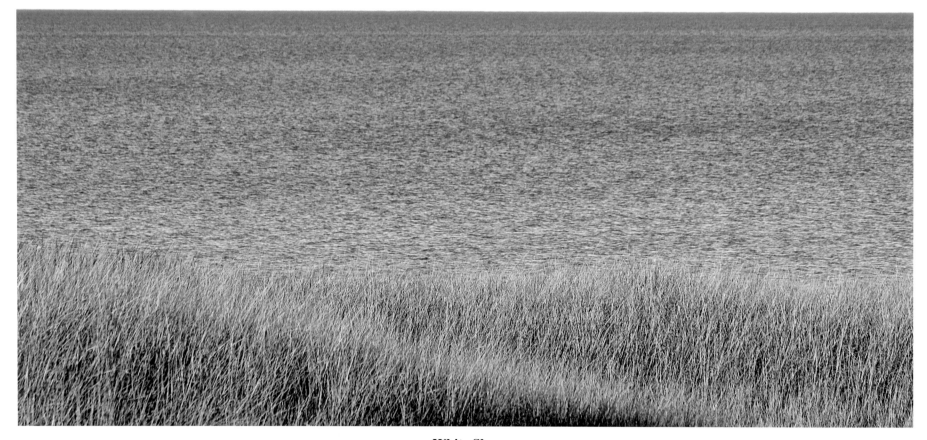

White Sky

Clear and crisp as a fall-ripened Minnesota apple, a perfect fall day is good enough to eat.

September 1, 2014, 6:43 PM, 116 mm

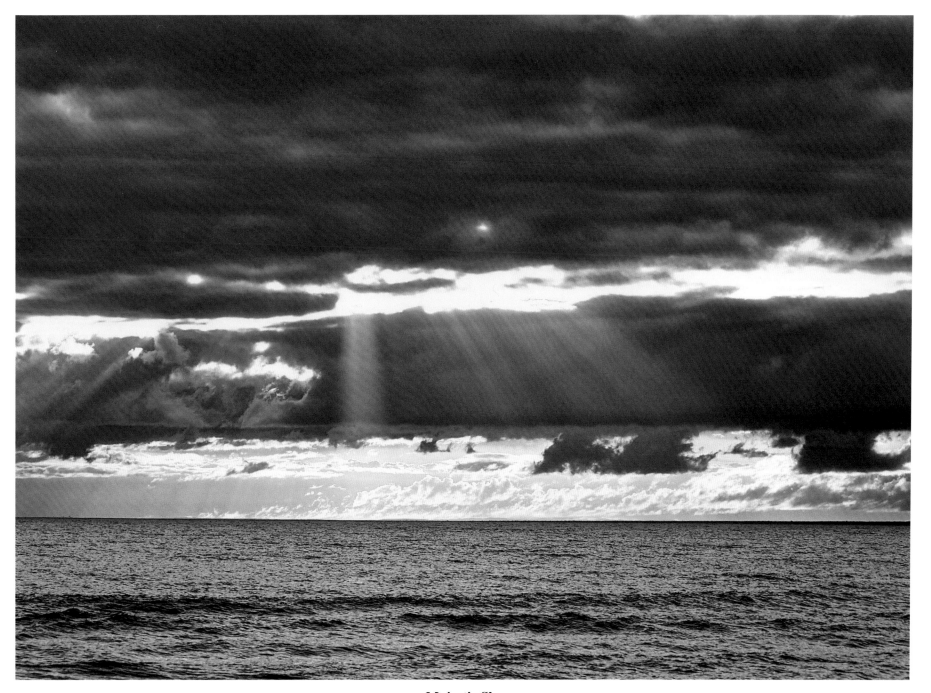

Majestic Sky

The dramatic light show above leaves scarcely a trace in the blue seas below.

September 21, 2014, 7:33 AM, 79 mm

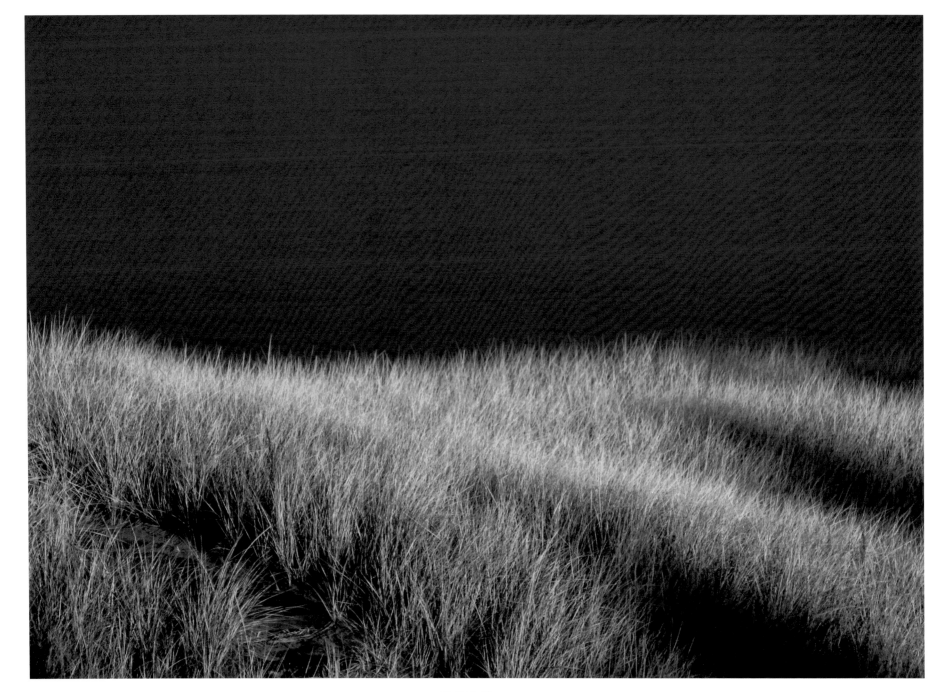

Fall Foliage

Late afternoon sunlight illuminates multi-colored dune grass against a backdrop of charcoal grey water.

October 23, 2011, 5:18 PM, 131 mm

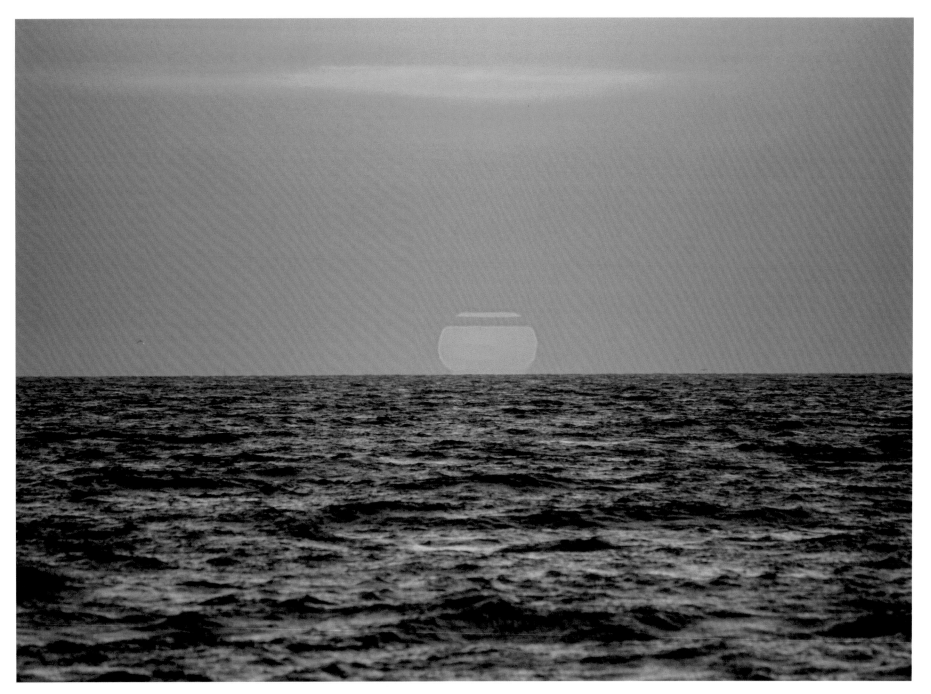

Steel Meets Fire

A cloud pierces the sun. The lake is beginning to cool down in defiance of the sun's warm rays.

September 3, 2017, 6:33 AM, 250 mm

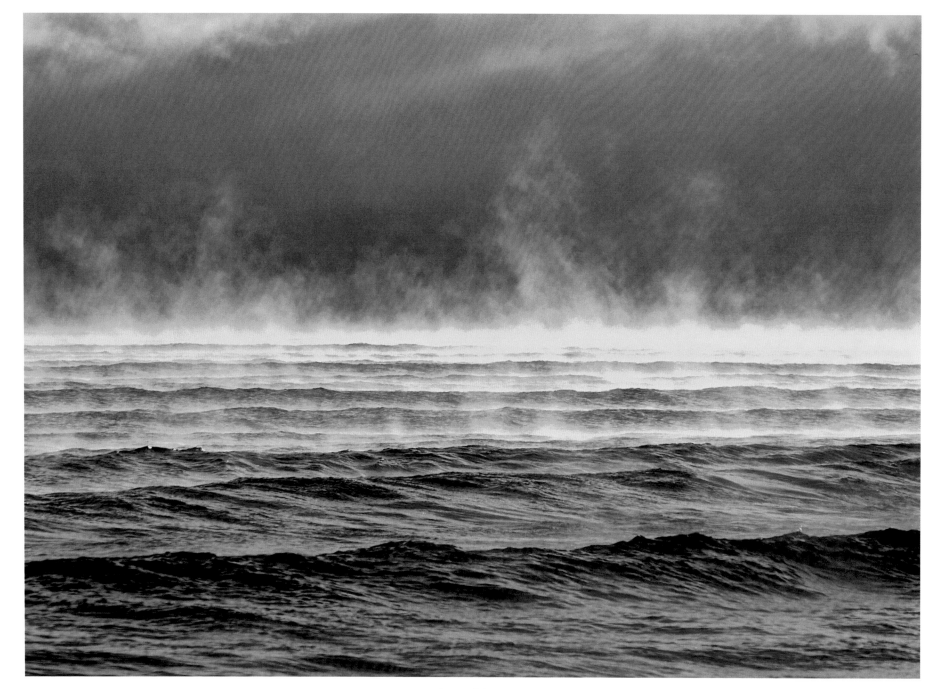

Apparitions

Vapors condense in the chilly air. The stage is set for gods to emerge in an early morning glow.

November 27, 2014, 9:17 AM, 187 mm

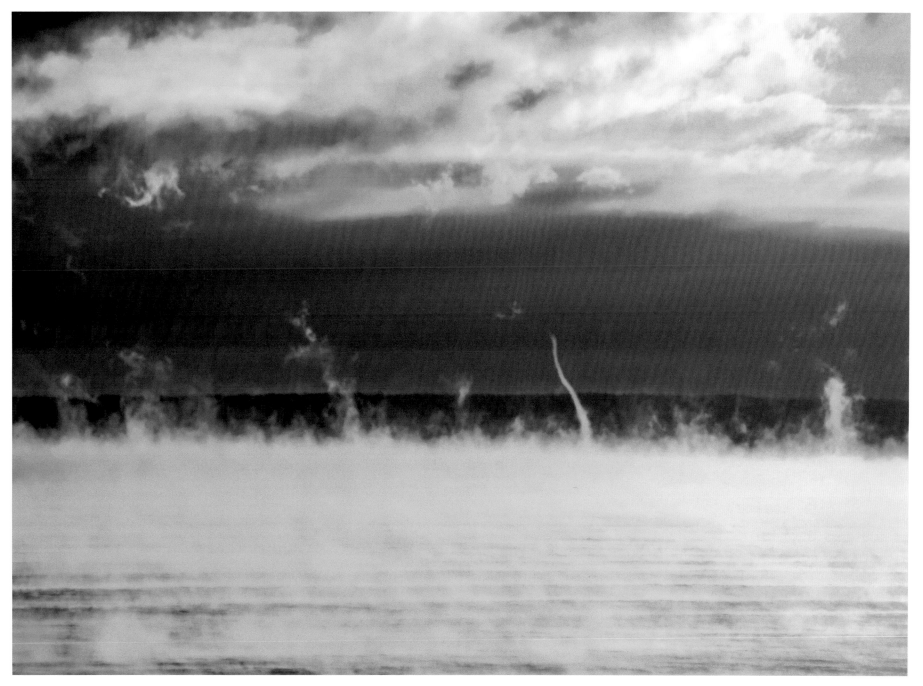

Whirling Dervishes

The Great Transmogrifier: she gives shape to spirits who float and dance above the water.

December 12, 2017, 8:59 AM, 300 mm

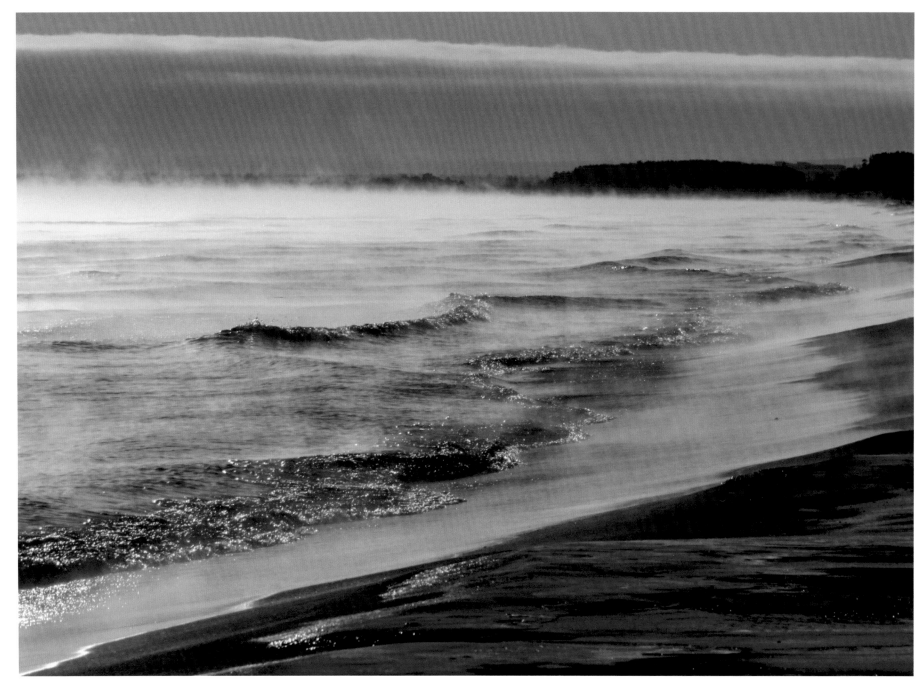

Approaching Shore

Winter rolls in, looks around, and rolls out, preferring to wait for colder air.

November 24, 2012, 9:24 AM, 123 mm

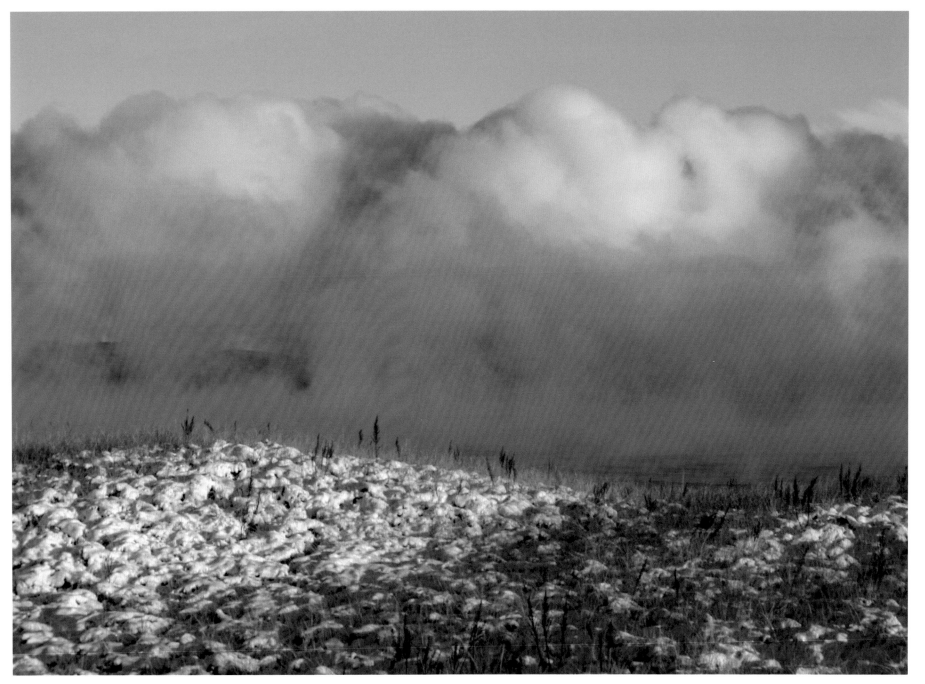

Cloud Bank

Blue skies and snow-covered dunes frame billowy clouds that keep winter at bay.

January 11, 2009, 1:19 PM, 215 mm

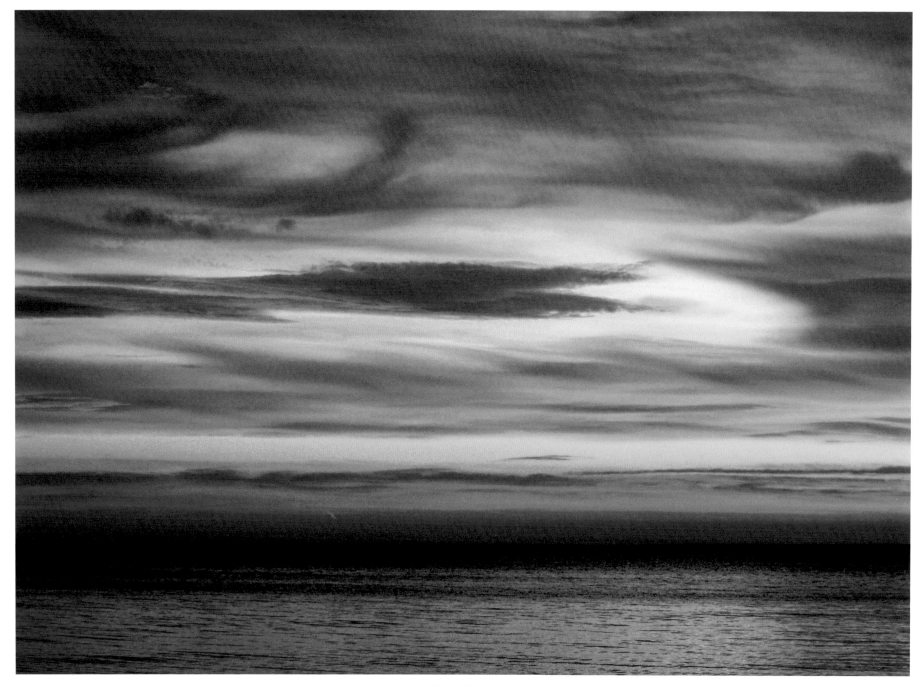

Heat Wave

What in the world! August-like colors and temperatures in December?

December 5, 2015, 8:23 AM, 55 mm

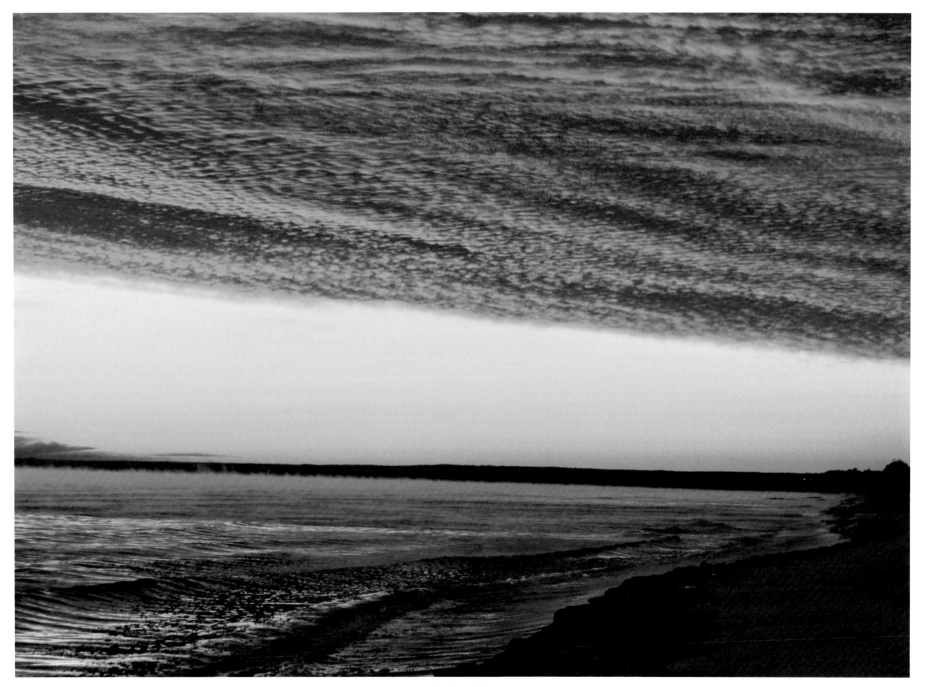

Quilted Sky

Fairies have prepared a quilt, pulling it over a sleepy shoreline for the upcoming winter.

December 12, 2017, 8:37 AM, 70 mm

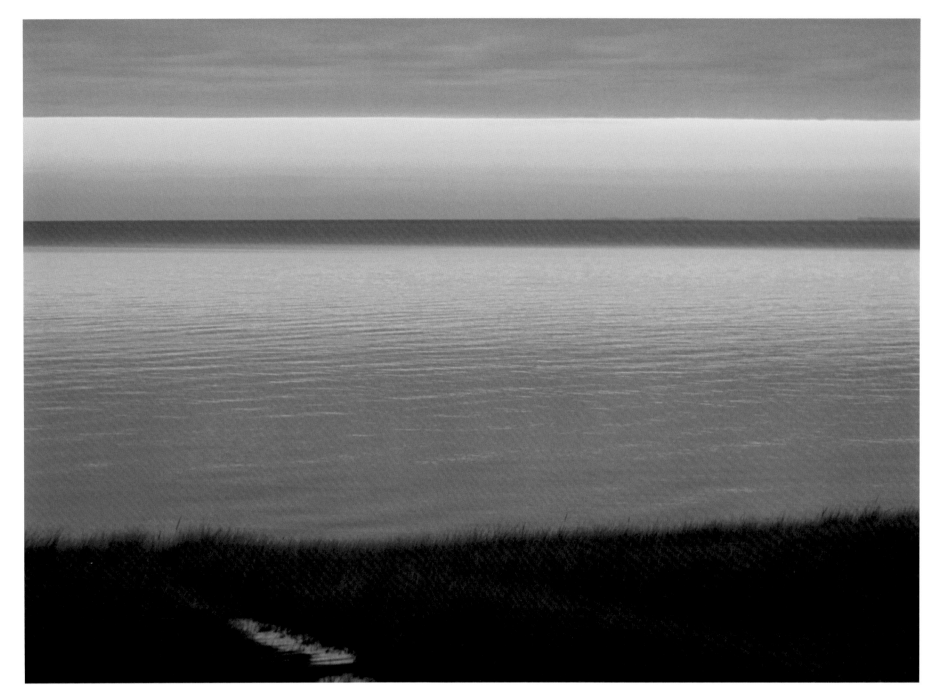

Autumn Blues

The lake, feeling the seasonal blues, would rather be roaring with gales of November laughter.

November 23, 2017, 5:18 PM, 70 mm

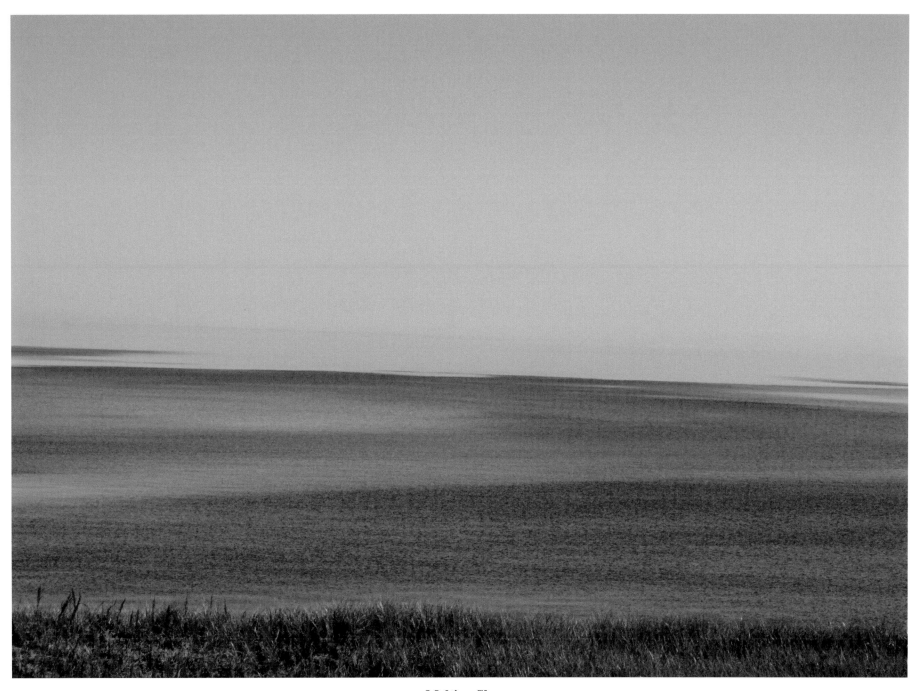

Melting Sky

Sky and lake become one when the horizon line falls asleep.

September 30, 2015, 10:26 AM, 65 mm

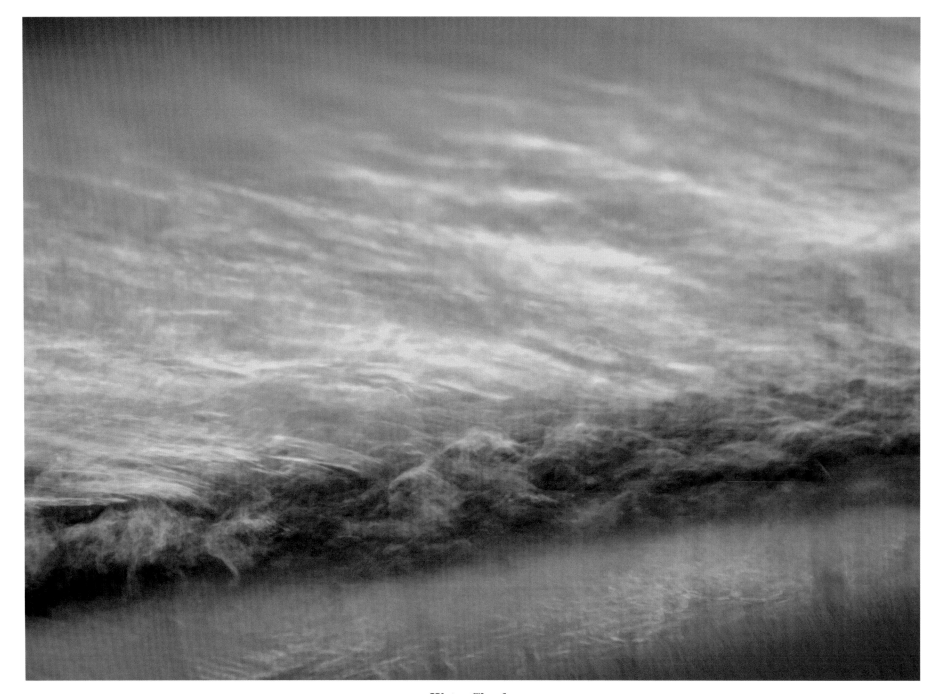

Water Clouds

Clouds are suspended by swirling surf before breaking into smithereens on the beach.

October 21, 2017, 7:27 AM, 300 mm

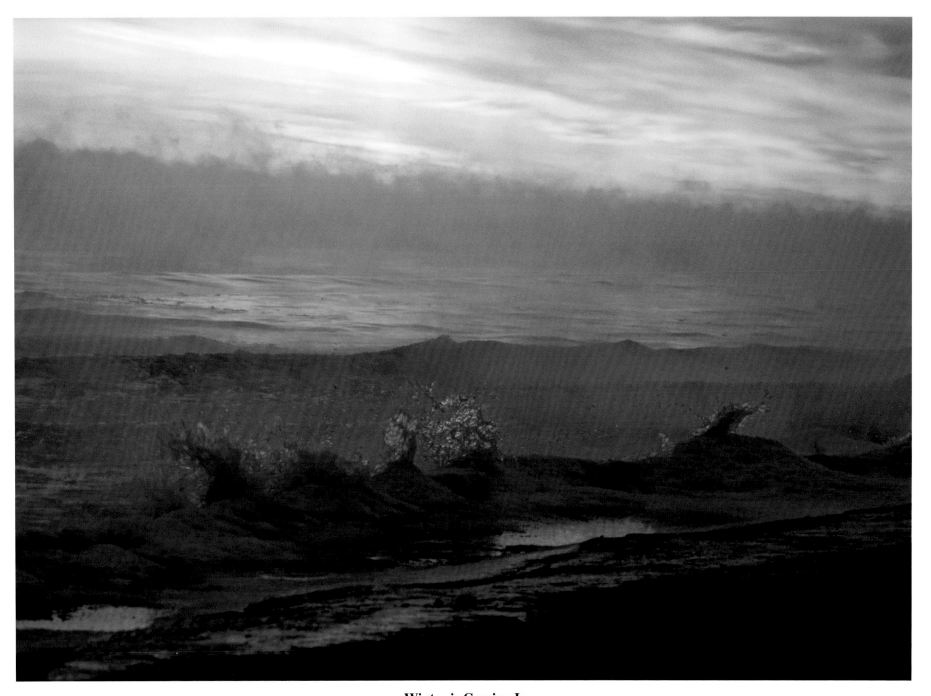

Winter is Coming In

My spirit is smiling because it is Ice Day today.

December 7, 2008, 8:29 AM, 79 mm

Going Forward

I love watching Lake Superior. Warm sand in one season is knee-deep ice and snow in another. The calm summer lake patterned with ripples is replaced by roaring waves in autumn. Bone-chilling air temperatures replace sweltering heat within minutes when the wind changes direction on a summer day. The horizon line, separating lake from sky, moves without rest like a magician's wand. I love watching these and many other changes taking place in this landscape from one season to the next.

The Lake Superior landscape is like a paint-filled artist's canvas. At times, when looking at the lake I feel as though I am in one of the world's great art museums looking at masterpieces. The only difference is that in contrast to a museum, each work of art on the lake is transient. It is here for an instant and then gone. The paint never dries.

Though I am thrilled to observe and document selected scenes during each of the seasons, I have become aware of another type of change taking place in the Lake Superior landscape. I have observed changes in ice cover taking place from year to year. Scientists confirm and expand my observations with rigorous study. Ice cover, water level, wind speed, storm intensity, precipitation and water temperature are undergoing progressive annual changes. Changes that were once observed in geologic time, covering thousands and millions of years, are now happening in time measurable in years and decades.

The year-to-year changes on Lake Superior are alarming. In contrast to the joy I feel when watching seasonal variation, I am deeply troubled by the annual changes. They foretell an uncertain and potentially inhospitable future. Not only is the delicate balance of the Park Point ecosystem at risk; the health of vast populations of plants and animals throughout the world is at risk. One unequivocal message is that humans are being tested for resilience, ingenuity and wisdom. Are humans tough enough, like dune grass, to survive and thrive, in the margins? Will humans adapt to conditions that are sure to be considerably harsher than the present? Time will tell. I expect that long before humans use their capacity to significantly reduce toxic dumping into the atmosphere, Lake Superior will roar up in a fury unlike anything we have experienced.

I pause from a sense of deep concern about the health of our environment to reflect on what I hold most sacred when looking at Lake Superior. Beauty in the moment is important. Regardless of change, whether it is seasonal or annual, our natural world is magnificent. Its beauty is worthy of being seen with open eyes and an open heart.

Paul Treuer

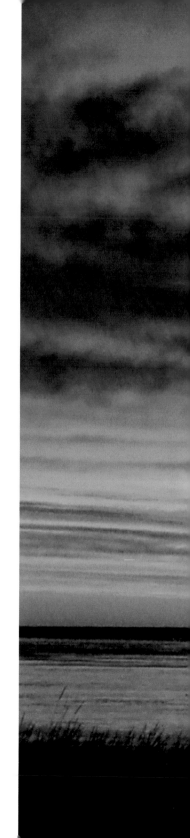

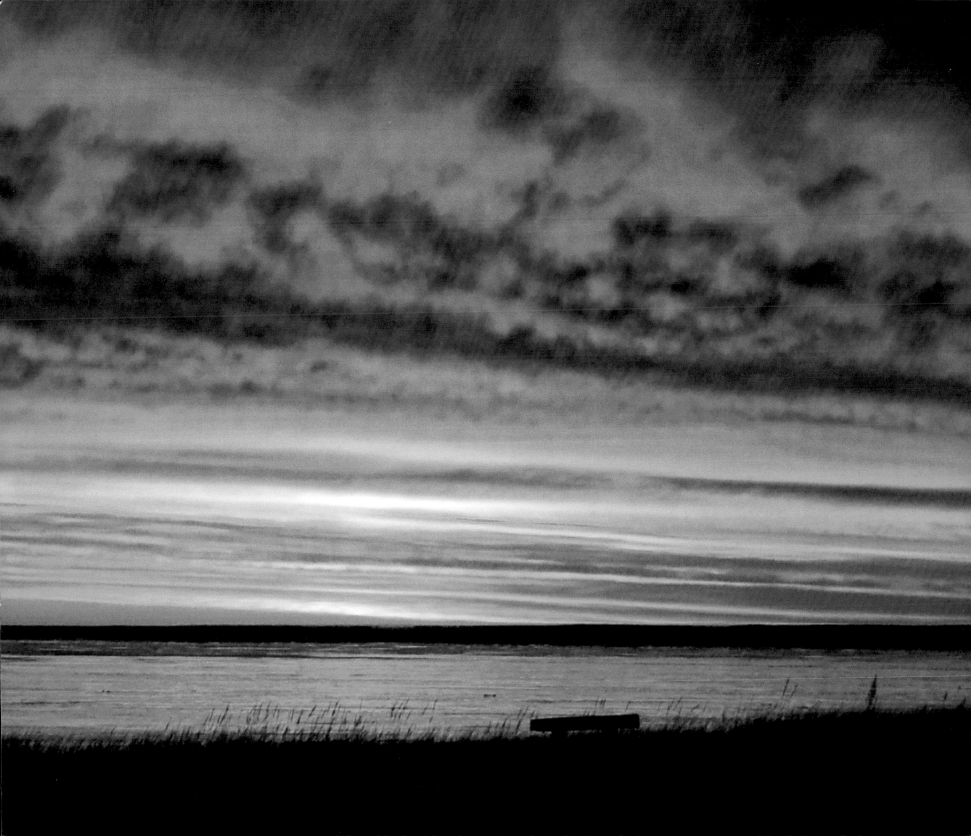

Acknowledgments

My immediate family spans four generations. Every one of the family members, from the oldest, who is 95, to the youngest, who is 8, has their own unique sense of wonder regarding Lake Superior. Their curiosity and excitement, ranging from quiet observation to active recreation, feeds my joy. Their observations sharpen my senses for seeing and feeling the beauty of the lake. I have an oil painting of the north shore of Lake Superior done by my maternal grandmother, Erlis Nelson. Not only does it show the lake in detail during a storm, it conveys her feelings for this landscape. My family's love of the lake is inseparable from mine.

Close friends, likewise, share with me their love for the lake through numerous outdoor activities. Whether kayaking, walking on the beach, taking photos, swimming, camping, painting pictures, exploring ice formations, or sitting and watching its broad expanse, friends deepen my bond with the lake. For this I am grateful.

Many individuals have helped with this book in various ways. Their support is like the juxtaposition of patterns and colors in one of my favorite images, "Divine Painting." It ranges from giving encouragement to create the book in the first place, to sharing the fun of photographing the lake's many moods, to reviewing photographs, to editing and designing the book, and to its publication. I thank everyone who has helped with the creation of this book. Your support made this book possible.

A special tip of the lens cap to my granddaughter Amelie Richard who named the photo "Peek-a-Boo."

The tightly knit community of Park Point is our home. It is a small town in which people are joined by a common bond of togetherness reinforced by a lift bridge that is often up when one is in a hurry to go someplace important. I appreciate the sense of community of Park Point and Duluth; people living here have a communal awareness of the lake.

As luck would have it, I recently crossed paths with a friend, Norton Stillman. We share a love of the book business reaching back to the 1960's. Our separate dreams intersected then as booksellers: they recently intersected when his book company, Nodin Press, published this book. I am honored that this book is associated with such a distinguished individual. I am also grateful to have been introduced by Norton to his editor, John Toren. What a gift! John's love of words and images is matched by his love of nature. John's editing was complimented by layout and graphic design done by a fellow Park Pointer, Natalija Walbridge. Natalija has been a joy to work with. She and her brother Charles, a professional photographer, have prepared the book for printing. Charles identified what I cherish most in everyone who has helped with this book when he wrote, "I love all the moods of that big lake."

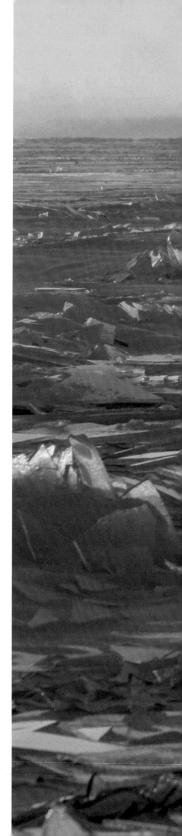

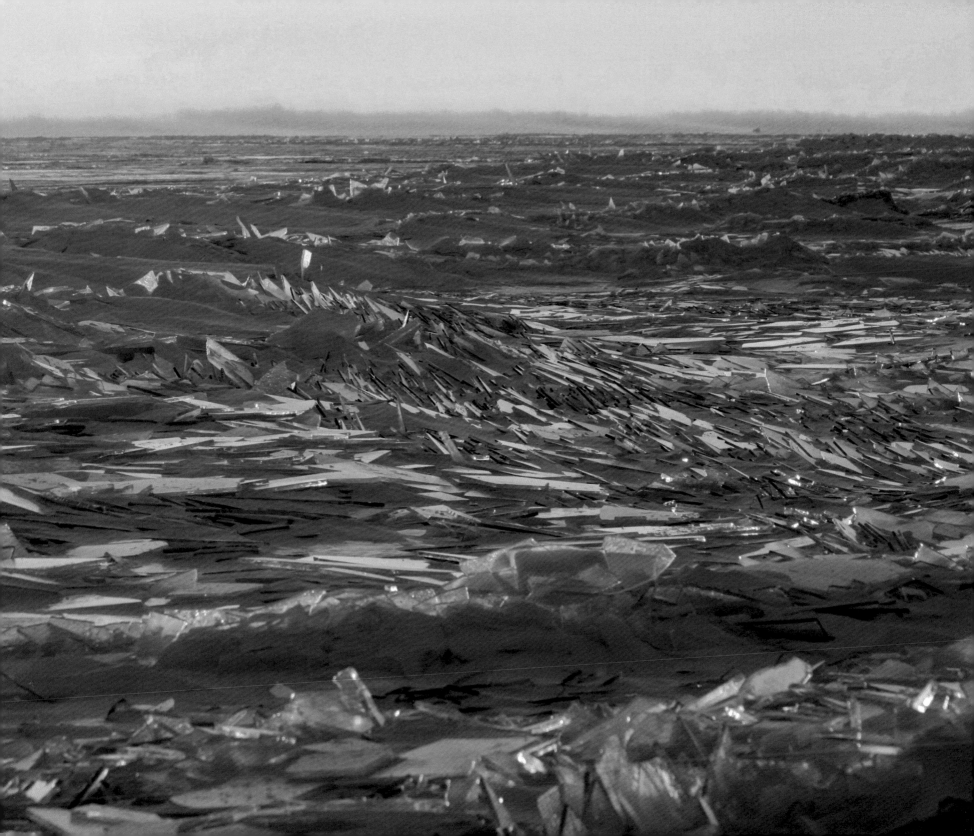

Superior Perspectives: *Views of Lake Superior from Park Point*

Living along the shores of Lake Superior is a breathtaking and humbling experience. She is at once fierce, joyful, unexpected, tranquil, determined, and fully alive. Paul captures the lake and her power beautifully. Superior Perspectives reminds us that daily living is a dynamic process - that even while we are still, our world is constantly changing. Our choice is not if we can stop it: it's how we choose to go along for the ride.

~ Emily Larson, Mayor, Duluth, Minnesota

If you love Lake Superior, then you must read this book. You will walk away with new knowledge, new appreciation, and a renewed sense of cherishing the lake. If you're a newcomer to the lake, then you're in for many surprises, great joy, and most assuredly a determination to experience the lake more fully yourself. Paul's love of the lake is palpable, and his knowledge brings readers to a new level of understanding and commitment to its future.

~ Ann Linnea, author of "Deep Water Passage: A Spiritual Journey at Midlife"

The big lake has persisted as a profound inspiration for artists, writers, and photographers for centuries. Paul Treuer's stunning photographs exude the elemental dynamism of this great water, while accompanying text offers a poignant message, a clear and impassioned alarm.

~ Martin DeWitt, Artist and Art Currator, Duluth, Minnesota

Paul's work reminds us of our important connection to this lake we call home. I just looked out my window at an amazing view of sun and cloud shadow on the Lake; it took my breath away.

~ Thomas Beery, Environmental Educator, Minnesota Sea Grant